D1243090

1 221- B3.53ᶜ

19

co

AUGUSTUS WALL CALLCOTT

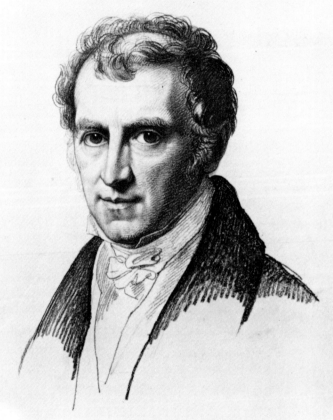

Augustus Wall Calcott Born at Kensington Gravel Pits Feb 20 - 1779.
Dresden August 7th. 1827 -

MW-DON

Augustus Wall
Callcott

DAVID BLAYNEY BROWN

Université d'Ottawa
BIBLOTHÈQUES
LIBRARIES
University of Ottawa

THE TATE GALLERY

ND
497
·C23
A4
1981

ISBN 0 905005 87 2
Published by order of the Trustees 1981
for the exhibition of 11 February–29 March 1981
Copyright © 1981 The Tate Gallery

Published by the Tate Gallery Publications Department
Millbank, London SW1P 4RG
Designed by Caroline Johnston
Printed in Great Britain by Balding + Mansell, Wisbech, Cambs.

Contents

cover
Augustus Wall Callcott
The Quay at Antwerp during the Fair Time 1826
(detail, cat.no.19)

frontispiece
Karl Vogel von Vogelstein (1788–1868)
Portrait of Callcott 1827
Kupferstich-kabinett, Staatliche Kunstsammlungen, Dresden

Foreword

Augustus Wall Callcott was widely recognised in his lifetime as Turner's chief follower and professional associate, but his work has been little studied, and this small exhibition is the first to be devoted to it. While the main purpose of reuniting Callcott and Turner must be to extend our appreciation of the artistic context in which Turner worked, we hope also that Callcott's pictures can be admired in their own right.

We are very grateful to Dr David Blayney Brown, of the Department of Western Art in the Ashmolean Museum, who has done a great deal of work on the artist, for making the selection and writing the catalogue.

We are also most grateful to all the lenders for their generosity.

ALAN BOWNESS, Director

Comparative illustrations

Augustus Wall Callcott

Apart from an important article by John Gage on Turner's 'academic friendship' with C.L. Eastlake,[1] Turner's relations with his fellow artists, even those who belonged to his immediate circle, have been little studied. This is partly because many of them, James Holworthy, George Jones, A.B. Johns, W.F. Wells, were not particularly compelling figures in their own right. Callcott's name, like theirs, has been preserved mainly as a footnote to Turner's, and until recently he has been one of the most completely forgotten artists of the British school. When mentioned at all, he has usually been described as Turner's chief follower and imitator, in Finberg's phrase his 'faithful disciple'.[2] Even if partly true, this has obscured Callcott's independent standing and achievement – which properly ranks far higher than that of most of Turner's other painter friends – and has been so far accepted as a commonplace that the historical evidence for their connection has never been fully assembled. The notes published here attempt firstly to provide a brief account of Callcott's life and career, and secondly to examine the real extent of his personal and professional relationship with his great contemporary.

Augustus Wall Callcott was born on 20 February 1779, in the hamlet of Kensington Gravel Pits, a small community named after its staple industry and then still surrounded by open fields. The Callcott family had been established there for two generations, in a house built by Callcott's grandfather, a bricklayer who, as he tells us in a fragmentary autobiography, 'had walked up to town from some place in Shropshire, in a pair of wooden shoes'.[3] Callcott's own father had continued in the building trade; he 'never rose . . . above the station of an ordinary tradesman', but being handsome and amusing, he made two good marriages, to 'persons both possessed of more fortune . . . than from his position in life he had a right to aspire to . . . the first eloped with him, and the second (my mother) married him against the urgent advice and wishes of her friends'.[4]

Callcott was brought up in an educated household, the creation of his mother, Charlotte Wall, the daughter of a prosperous butcher of Market Street, St James's: 'In every room of the house were to be found prints after the best masters . . . tolerable oil copies from the Dutch or Flemish masters. There was also a considerable number of works by the best English authors'.[5] Callcott's artistic ambitions were first inspired by the sight of Thomas Stothard's illustrations to *Robinson Crusoe*, which appeared in 1781,[6] and by the time he was attending dame's school in

Silver Street, Kensington, he was 'trying to draw brewer's horses' and tackling his first 'drawing in colours, an imaginary farm'.[7] His family, however, were at first determined that he should become a musician, encouraged by the promising career of his elder brother, John, as a composer and organist. Thus at the age of six Augustus was 'drilled by my sisters to wail for hours and hours at a time the treble of Handel's "Wretched Lovers"',[8] and a year later was placed for six years in the choir at Westminster Abbey, where he received 'for the total want of my education, music included . . ., £7 a year and 3 yds & ½ of coarse black baize'.[9]

But soon his family relented. His father, and half-brother by his father's first marriage, were connected with the Corresponding Society and the political reformer, Horne Tooke, and, through these, procured Augustus his first introduction to a practising artist, the portrait painter Mason Chamberlin, who was also a member. As Chamberlin died in 1787, Callcott must have met him at the age of eight or even younger, and can have profited little by the encounter. Later, however, the Corresponding Society may have provided an initial link with John Hoppner, under whom Callcott began to study around the same time as he enrolled as a student at the Royal Academy in 1797. James Northcote told Hazlitt that Hoppner had once taken him to the hustings to vote for Horne Tooke,[10] so clearly he was a supporter of his, and could have known others active in the Society who were acquainted with Callcott's family.

Of Callcott's days at the Academy Schools we know nothing save his opinion of Fuseli as a lecturer, which is over-enthusiastic in its parody: 'His sentences', Callcott tells us, 'are a kind of Extermination of Ideas, the Extortion of a barren invention, the Exudation of Vanity and self-conceit, a Prodigality of words and Frugality of Ideas, his fulminating sentences a garrulity, a loquacity of style, gorbellied, overgrown . . . Mr. Fuzelly's Ideas are too outrageously hid and entombed in a wilderness of words that they may not improperly be said to lie in ambush and rush upon you by surprise'.[11] This would have been a very private outburst; Callcott and Fuseli seem to have got on well together, and it was to Callcott that the Professor of Painting made his famous remark that Constable's landscapes made him call for his greatcoat and umbrella.[12] Moreover, although the close of the eighteenth century was not a particularly glorious period in the history of the Schools, Callcott cannot have been alienated by his studies there, for he was to become a devoted Academy man, joining Turner in defending its prerogatives against the incursions of individual connoisseurs like Sir George Beaumont and

Richard Payne Knight, and of a rival organisation such as the British Institution.

At least as important, however, must have been Callcott's contemporaneous work in Hoppner's studio, especially as his earliest aspirations were towards portraiture. Callcott's first exhibits at the Academy were portraits, beginning with a 'Miss Roberts' in 1799, and those of his early portraits which survive in the original or in photographs show Hoppner's influence in their directness and painterly technique. Hoppner was far from uninterested in landscape, and may well have encouraged Callcott to concentrate upon it. Like his own master, Reynolds, Hoppner himself practised landscape as a diversion, and was an admirer and imitator of Gainsborough, by whom he owned at least eleven drawings as well as a copy of Wells and Laporte.[13] The Gainsboroughs seem to have been practically the only drawings he possessed by another artist, and their impact on the young Callcott, rummaging around his studio, would have been all the greater. Callcott himself was to produce several effective pastiches of Gainsborough in chalks on blue paper, which were included in F.L.T. Francia's *Studies of Landscape*, published in soft-ground etchings in 1810.

Callcott would have met Francia through Girtin's Sketching Club, which he must have joined before November 1801, when Girtin left for Paris, for a set of seven drawings of 'An Ancient Castle', the prescribed subject for one of the meetings, includes examples by both Callcott and Girtin.[14] Callcott was not a founder member, and his membership was probably restricted to 1801 itself, for during that year he was living at 24 Leicester Square, close to the Great Newport Street lodgings of Robert Ker Porter, where the Club's first meetings had been held. He did not enjoy living in the city, and the following year returned to the Gravel Pits, where he was to spend the rest of his life; in 1806 he told Farington that he had 'Found an advantage in residing a little way from London as He is not now so liable to have His time invaded by Loungers who in London were accustomed to call upon Him to look over His Portfolios'.[15]

This remark would suggest that drawings constituted an important part of Callcott's early production. One of his first major commissions was from Edward, Viscount Lascelles in 1804, for two Welsh drawings and one other, but it is clear that Callcott was not a natural draughtsman. As late as 1833 he was writing to Charles Barry about his 'inexperience in the use of water color',[16] and charming as his comparatively few known drawings can be, they display no consistent style; once watercolour ceased to be the vogue he described to Farington in 1805,[17] he seems to have gladly abandoned it as a regular practice. A notable omission from

Callcott's early training as a landscapist, which must partly account for his unease as a draughtsman, was any contact with Dr Monro; possibly he was too young to belong completely to the generation of Turner and Girtin, and to share in the sessions of mutual copying held in the doctor's Adelphi house. This lack of grounding, both in the topographical tradition and in the imaginative use of watercolour, had more far-reaching consequences. Together with his encounters with Gainsborough in Hoppner's studio, it helps to explain why Callcott, contrary to the most advanced trends in landscape painting, continued to draw inspiration largely from the picturesque, thinking in terms of imaginary compositions rather than expressive renderings of real nature, and relying for the focal points of his pictures on incidents of genre rather than on outstanding natural features. His reactions to Wales, as expressed to the watercolourist James Holworthy after his visit in 1804 in search of subjects for Lord Lascelles, are revealing: 'too monotonous and too little diversified by woods, wanting principle features in building and tiresome for any but painters to travel through'.[18] It was as a pastoral and genre painter emerging from the picturesque tradition, alive to the fascination both of sublime and historic, and of naturalistic landscape, but aware that neither was his most congenial *métier*, that Callcott emerged during the years between his membership of the Sketching Club and the publication of Francia's *Studies*.

Callcott's picturesque style was first fully expounded in 'The Water Mill' (No.2), which won a considerable *succès d'estime* at the Royal Academy in 1805. It was bought before the exhibition opened by Sir John Leicester, apparently on the advice of the painter Henry Thomson. Judging by surviving fragments of Callcott's diary for 1805,[19] Thomson, and William Owen and John Opie, were by now his closest professional friends and confidants. All were senior in age and academic qualifications, but at least by his own account, Callcott was accepted as their equal; on one occasion he was himself the host at a dinner for them, which Hoppner also attended. Turner is not mentioned as a friend in the 1805 diary, and nor are William Mulready or John Linnell, younger artists whom Callcott came to know very well when they moved to the Gravel Pits in 1809.

It was Thomson who first brought Callcott to Farington's notice, telling him that he 'will press hard upon Turner, – and that He is a modest well behaved young man'.[20] Callcott's personality certainly included a gift for getting on well with his elders – as early as 1799 he had suffered an 'accusation of courtier'[21] – and he was also at ease with higher levels of society, having benefited much as a young man from his family's

connections with nearby Holland House. The Callcotts had traditionally undertaken building work for the Hollands, and one of Augustus's uncles had been educated at Harrow and sent into the Navy at their expense. Callcott himself was constantly received at Holland House, both as friend and painter-retainer – repairing pictures and, on one occasion, with John Jackson, copying a Lawrence portrait for the collection[22] – and the preponderance of great Whig families among his patrons must have been largely due to the Hollands. His first commissions from aristocratic patrons had included one from Lord Lansdowne in 1802, at least three years before his name became widely known, and another from Lord William Russell in 1805; William Chamberlayne, his host at Southampton in 1810 (see Nos 11 and 12), was actually a country neighbour and heir of Lady Holland, and a Whig politician who erected a monument to Charles James Fox in his grounds; and later patrons were to include the Whig prime minister, Earl Grey, and his Northumberland neighbour and adviser Sir John Swinburne.

In 1805 Callcott sold works to Richard Payne Knight as well as to Sir John Leicester and Viscount Lascelles, and thenceforth he would almost uninterruptedly command the attention of the leading patrons of his day, whether great landed magnates or the new commercial collectors such as John Sheepshanks and Robert Vernon. His patrons found him adaptable, if rather a slow worker, and appreciated his moderate prices. Although he was well aware that his work tended to attract comparison with Turner's, only in 1819 did he raise his prices to a level commensurate with his, charging Earl Grey 500 guineas for 'Rotterdam' (No.17), the same sum Turner had received for the 'Dort' in 1818. Earlier, his prices were considerably lower; for a large and elaborate canvas like 'Market Day' (No.5), Sir John Leicester seems to have paid 150 guineas, as against 315 for Turner's 'Shipwreck', which, though to the modern eye an immeasurably greater work of art, can hardly have occupied any more time or effort in the painting. Callcott seems not to have heeded at all Hoppner's advice, given to him in 1805 *à propos* the new British Institution, that 'painters ought to try their earnestness by demanding very large prices',[23] and late in life his reasonable fees were still a matter of pride; linking, in a letter to Francis Chantrey, Richard Wilson's prices to those charged by 'almost any of us now', he added, 'I won't name the exceptions – I can only say that I am not one'.[24]

But any temptation to regard Callcott's success during his lifetime as that of a kind of bargain-basement Turner must be resisted. The connections between the two artists' work will be discussed elsewhere, but suffice it to say here that Callcott's reputation was first established

before he exhibited any pictures reflecting Turner's influence, and, in so far as it did become apparent, Callcott at first suffered more than he gained by the comparison. The two coast scenes he exhibited at the Academy in 1806 (see Nos 3 and 4) soon attracted the hostility of Sir George Beaumont, who objected to their 'white look',[25] and indeed they became the source of all the baronet's attacks on Turner and his followers as 'white painters'. Sustained over several years, these undoubtedly hindered Callcott's progress, but not as much as he liked to pretend; he made the most of his role as injured party, complaining constantly to Farington and refusing to exhibit at the Academy in 1813 and 1814, largely because it enabled him to air wider protests about the British Institution, whose ambitious policies threatened the traditional ascendancy of the Academy.

Callcott was elected Associate of the Academy in 1806, and Academician in 1810 in place of Paul Sandby. The Academy gave him, as a bachelor, a social niche, as did certain of his patrons. Callcott was not given to sketching tours, and their hospitality provided his main escapes from his Kensington studio. In 1806, following their purchases of his coast scenes, Callcott, accompanied by Thomson, visited Sir John Leicester at Tabley and Thomas Lister Parker at Browsholme Hall; he was probably at both houses again in 1808. In 1810 he stayed with William Chamberlayne at Weston Grove, near Southampton (see Nos 11 and 12), where he painted for two months, and two years later he was again in Hampshire, with Mr Heathcote at Embly, near Romsey; thence he travelled on to Stourhead to visit Sir Richard Colt Hoare, and to Devon, to Mr Carey of Torre Abbey. In 1815, after Sir John Swinburne purchased his first important marine picture, 'Passage and Luggage Boats' (whereabouts unknown), he stayed '8 or 10 weeks' with him in Northumberland, the first of several visits;[26] and, for the next decade, he usually followed months of hard work on the large marines he was then exhibiting at the Academy by an autumn holiday with the patron concerned.

With the exhibition of 'Passage and Luggage Boats' in 1815, Callcott's career turned a new corner. Although he had produced a certain number of marines, notably the two coast scenes of 1806, 'Itchen Ferry' of 1811 (No.12) and a copy of Turner's 1807 'Junction of the Thames and the Medway' (see No.7), these had been incidental to his main work as a landscapist. He would have absorbed an interest in the sea from his study of Turner, and perhaps also from Hoppner, whose spirited coast scene, 'A Gale of Wind', is in the Tate Gallery; and Callcott's marines may further be seen as an attempt, analogous to Turner's, to rival and

reinterpret the old masters. Certain of his earlier landscapes display that clear intention, notably several large historic landscapes in imitation of Dughet and Claude (ie. fig.4), and pastorals acknowledging, variously, Ruysdael, Hobbema and Cuyp; the marines are likewise essays in the Dutch taste, stimulated by the exhibition of Dutch pictures at the British Institution in 1815, and by the even greater prestige of the school following the Prince Regent's acquisition of the Baring collection, in which it was richly represented, the previous year. Nevertheless, the complete change of direction which Callcott took in 1815 was more the result of pressure from his patrons than of a personal choice. All the marine and river scenes shown by him at the Academy from that year until 1830, and the majority of unexhibited ones of that period, were commissioned works; the success of each year's exhibit invariably led to several orders for similar pictures. There is no doubt that Callcott rose magnificently to the challenge. Wisely, he chose to exhibit only one painting a year between 1815 and 1824, and worked very slowly; of 'The Mouth of the Tyne' (whereabouts unknown; fig.6), shown in 1818, he told William Owen that 'He could not paint such a picture in less than 6 months, whereas Turner *wd.* paint such as "The View of Dort" in a month',[27] and Earl Grey had to wait two years for 'Rotterdam' (No.17). His marines acquired for Callcott something of the significance that the six-footers had for Constable – criteria by which his abilities could be judged and his image established – and it proved to be these, rather than his landscapes, that won him the most universal acclaim and represented him in every major collection.

In connection with Earl Grey's 'Rotterdam' (No.17) and the Duke of Bedford's 'Antwerp Quay' (No.19), Callcott paid short visits to the continent in 1818 and 1824, but by comparison with many artists of his time he was not widely travelled, and before embarking on a long honeymoon in 1827 following his marriage to the traveller and authoress Maria Graham, his only significant trip outside the British Isles had been a visit to Paris with his friend Owen in 1815. We know from his diary[28] that Callcott met most of the leading French painters including David, Guérin, Gros and Gérard, and looked critically at their work; he recorded fewer personal opinions of the masterpieces he saw in Napoleon's Louvre, although on his return he told Farington that 'the Galleries at Paris afforded a fine opportunity for comparing the works of art of the different schools'.[29]

Another such opportunity came in 1827–8, when Callcott passed an extended honeymoon in Germany and Italy. Although many of Callcott's friends would have agreed with Lady Holland in considering

'the intrepid Mrs. Graham' a 'bad prospect' for him,[30] she possessed excellent credentials for an artistic marriage. In Rome with her first husband in 1819 she had come to know the colony of English artists working in the city, especially the young Charles Eastlake, who became something of a protegé, and, at the same time, she had written her pioneering *Memoirs of the Life of Nicholas Poussin*, published the following year as the first account of the artist in English. Her tastes in contemporary painting were educated and advanced, and one may well wonder what was her estimate of her new husband's art. In a letter of 1836 to her German acquaintance August Kestner, she seems to have been slightly disparaging, and as Kestner had apparently imagined that his 'principal pieces were sea pieces', she had probably drawn a veil over much of Callcott's work.[31] 'Is it not odd', Kestner replied, 'that I am not able to form any idea in myself about his manner, not having seen any of his works, excepting a very few in prints, but in a very small shape'.[32] Eastlake, despite his friendship with Maria, and with Callcott himself in Rome in 1828, was kept similarly in the dark; 'I long to see what will be the produce of the year and see what Mr. Callcott has', he wrote to Maria from Rome in 1829. 'After all I saw none of his grand works when I was in England and have an idea of every English talent but his'.[33] But whatever she thought of Callcott's own work, Maria respected his knowledge of art, and the tour of galleries and churches in Germany and Italy which made their honeymoon was in every sense a joint project. Their meetings with pioneers of art history such as Sulpiz and Melchior Boisserée and Carlo Lasinio, with professional curators like Georg von Dillis in Munich and Vincenzo Camuccini in Rome, with artists including Cornelius, Friedrich, Overbeck, Koch and Dahl, with the architect Leo von Klenze and the sculptor Thorvaldsen, brought the Callcotts to the forefront of English taste and connoisseurship.[34] On returning to London, Maria drew upon her tour for her series of *Essays towards the History of Painting*, published in 1836 and 1838, and her *Description of the Chapel of the Annunziata del Arena* of 1835, while Callcott also proved himself a stimulating and open-minded commentator about painting. Samuel Palmer and John Linnell recalled visiting collections with him, and in 1834 Constable, who had just missed meeting him at Petworth, wrote to C.R. Leslie that 'I should have liked to have heard Callcott's conversation on the galleries, for I want to know what fine pictures are when divested or apart from their genius'.[35] Dr Waagen, who spent a 'very agreeable day' with Callcott in 1838, was impressed by his 'love of art in all its branches',[36] while J.D. Passavant, who had stayed with the Callcotts for several days in 1832, being taken by them to Apsley House

and to Cambridge to see the new Fitzwilliam Museum, remembered that their 'friendly interest was as beneficial, as their society was instructive to my plans'.[37]

By the early 1830s, Maria Callcott was suffering from tuberculosis, and, so as not to be deprived from the company of her friends, she established a salon in her own rooms at Kensington. As with most of the best salons, the husband played a secondary role; the Redgraves recalled that 'Lady Callcott mostly supported the conversation. She was somewhat imperious in her state chamber, the painter being more of a silent listener, until some incident of travel, some question of art, raised him up to earnest interest or wise remark'.[38] Callcott was, however, more forthcoming on the paintings produced by his fellow artists, and, as the Redgraves added, 'always seemed interested in the progress of the young; being quite willing to communicate to them his art lore, and to advise them on the progress of their pictures, and for his sake the young painters made it a rule to take their works on the morning of sending in to the Academy, and to range them before the sick lady . . . that she might have a sight at least of some of the coming exhibition'.[39]

Callcott's reputation for artistic sagacity kept him much in demand on committees during his latter years. From December, 1836, he sat with Eastlake, Chantrey and Charles Cockerell on the controlling board of the Government Schools of Design, to which he would have brought practical knowledge of the state-run art schools of Prussia and Bavaria which he had visited in 1827; a friend of William Dyce, he may have been responsible for recruiting him to the committee, and, with Eastlake, Chantrey, Cockerell and John Papworth he shared the teaching at the school established at Somerset House, of which Dyce was director from 1838 to 1843. In 1841 Callcott, with the P.R.A., Martin Archer Shee, and Eastlake, Henry Howard and William Etty, was elected to the committee instituted by Sir Robert Peel to review purchases for the National Gallery, and two years later he was invited, but refused owing to bad health, to be one of the judges of the competition for fresco designs for the new Westminster Hall – ironically, both because his recollections of modern German fresco would have added weight to his opinions, and, in a different sense, because Lord Melbourne had suggested, to annoy B.R. Haydon, that Callcott himself should paint the decorations. 'My Lord – a landscape painter!' shouted Haydon[40], who already disliked Callcott and had been weaving tales of him 'corrupting' Lord Melbourne after dinner at Lord Holland's.[41] Malign though Haydon's picture is, Callcott was by now indisputably powerful. Although he had failed to be elected P.R.A. on the death of Lawrence in 1830, he was knighted in 1837 and appointed

Surveyor of the Queen's Pictures in 1843, and the close friendship he and Lady Callcott shared with two members of the Household, Miss Marianne Skerrett, Her Majesty's secretary, and Lady Lansdowne, Mistress of the Robes, gave him additional influence at court.

It might be thought that his various responsibilities would have restricted Callcott's practice of his art, but, unlike Eastlake, he had no intention of ceasing to paint so as to devote himself to an administrative career, and it was perhaps only the quality, certainly not the quantity, of his output which suffered from other demands on his time. Indeed Callcott became if anything more productive during the 1830s, and in contrast to his habit, between 1816 and 1825, of showing only one work a year at the Academy, he now sometimes sent the full eight allowed by the rules, while continuing to produce a considerable number of pictures on private commission. At the same time, encouraged perhaps by the precedent of Turner's exhibitions in his own gallery, he began to show his exhibits in his studio before submitting them to the Academy. These private views were glittering occasions; the Redgraves recalled that 'the occupants of lines of carriages' usually waited their turn to be admitted,[42] and, reading Maria Callcott's later journals, one senses the gleam in her eye as she lists the visitors – once in 1829 a gratifying queue of thirty-seven people trying to squeeze in at once, including the Bedfords, the Staffords, the Hollands, the Dacres, the Westmacotts, the Sothebys, the Chantreys, the Palgraves and others no less titled or distinguished.[43]

Callcott was just as assiduous in cultivating the new patrons from the commercial middle class – Robert Vernon, John Sheepshanks and George Knott were among his friends – and in deference to this growing market, much of his later work became simpler in handling, and more familiar and popular in subject – in the Redgraves' words 'suited to the appreciation of his public, and not beyond their comprehension'.[44] Genre played an important part in a number of his landscapes of the 1830s, and humorous or sentimental subject pieces of cabinet size such as 'Anne Page and Slender', 'Launce and his Dog' and 'Falstaff and Simple', or in a less literary vein, 'The Way-Worn Traveller', were added to a range of English and continental landscapes, marines and river scenes in the Dutch and grander landscapes in the Claudian taste, and history pictures. At no time had Callcott's energies been deployed more widely, but it is impossible not to conclude that his imagination was often unequal to the challenges he confronted; many of his late pictures are redeemed only by their technical skill.

Nevertheless, with the exception of his two huge historical compositions, 'Raphael and the Fornarina' (No.24) and 'Milton dictating

to his Daughters', shown at the Academy in 1837 and 1840, Callcott's work continued to be well received by the critics, who were usually eager to defend his ventures into unfamiliar subject matter, if only as marks of his brilliant variety. As late as 1854, ten years after his death, the editor of 'The Vernon Gallery of British Art', a compendium of pictures from the collection of Robert Vernon now in the Tate Gallery, could still carry praise to the extreme when discussing Callcott's genre pieces; an example like 'The Way-Worn Traveller' of 1835 was to be seen as a curiosity produced as a *jeu d'esprit* by a more powerful mind, just as 'Raffaelle, the "divine" as he has sometimes been called . . . even Raffaelle descended from the highest throne whereon painter ever sat to decorate the walls of a palace with ornamental designs'.[45] Callcott's last pictures, bland, uncluttered, sometimes still faintly Turnerian but without iconographical or emotional complications, sometimes animated by a simple thread of narrative, perfectly met the requirements of a large and prosperous market, and none put their appeal better than Mr Manson, auctioning (for £997) a lost 'English Landscape Composition' from George Knott's collection in 1845; 'With what agreeable and delicious sensations must Mr. Knott have enjoyed the repose of his home in the tranquil contemplation of landscapes like those of Sir A.W. Callcott, when he returned to it from the bustle and anxiety of the commercial pursuits in which he was engaged'.[46] And one might add, lest this seems unduly patronising, that it was not only such as Mr Knott who found consolation in an artist who, as one reviewer put it in 1832, 'views nature with a kindly and enquiring eye, and is in painting much what Goldsmith was in poetry';[47] Callcott's pictures continued to find aristocratic purchasers, and these, and indeed Prince Albert himself, were among the most enthusiastic bidders at the executors' sale held after his death in 1845.

<p style="text-align:center">* * *</p>

It was unfortunate that Callcott's later pictures, and their uncritical reviews in the press, alone served to give the young Ruskin his impression of the artist. Callcott died a year after the publication of the first volume of *Modern Painters*, and could thus have read its damning indictment: 'On the works of Callcott', Ruskin had written, 'I should look with far less respect. I see not any preference or affection in the artist: there is no tendency with which we can sympathise, nor does there appear any sign of inspiration, effort or enjoyment in any one of his works. He appears to have completed them methodically, to have been content with them when completed, to have thought them good,

legitimate, regular pictures, perhaps in some respects better than nature. He painted everything tolerably, and nothing excellently, he has given us no gift, struck for us no light, and though he has produced one or two valuable works . . . they will, I believe in future have no place among those considered representatives of the English school'.[48]

That Ruskin's forecast proved correct is indisputable, but how far the complete reversal of Callcott's critical fortunes during the past century and a half can be attributed to a genuine recognition of his weaknesses, and how much to Ruskin's own words, is difficult to determine. What is certain is that Ruskin's assessment was based on partial evidence. He was unborn when the finest of Callcott's pictures were exhibited, and the first major retrospective exhibition of Callcott's work was held by the British Institution in 1845, two years after Ruskin had pronounced in *Modern Painters*. Even that exhibition, and the selections of pictures chosen for the Manchester Art Treasures and International Exhibitions of 1857 and 1862, and for the Royal Academy in 1875, concentrated on the later work, and none of Callcott's early landscapes, and very few of his large marines, were publicly exhibited after their first showings; his masterpiece 'The Pool of London' (No.15), to whose beauty Ruskin could hardly have remained immune, appeared for the first time since 1816 at the International Exhibition in 1862.

The present exhibition is therefore unashamedly biased towards Callcott's work before his marriage in 1827 and includes only a very selective choice of pictures painted after his return from Italy in 1828. Its main purpose is to reunite Turner with his chief friend, rival and follower, so that our appreciation of the context in which Turner operated, and developed his keen competitive spirit, may be a little enlarged. It is not the intention to pluck Callcott from the shadows and promote him as a representative of an 'alternative' tradition, as has been done in recent years with certain continental artists of the late seventeenth and eighteenth centuries – although, as we shall see, that is just what the governors of the British Institution tried to do with him in 1805. Nor would one wish to make any extravagant claims for Callcott's art, for it will be readily apparent that his pictures are works of skill and craftsmanship rather than genius, and but rarely display the flair and imagination that might be expected from a painter who once stirred Farington's guests with the dictum 'Novelty is the essence of art'.[49] Nevertheless the skill and craftsmanship can be of a very high order indeed; Callcott has scarcely deserved the oblivion to which Ruskin consigned him, and it is high time that his pictures were rehabilitated among 'those considered representatives of the English school'.

Notes and references

1 Gage, 1968, pp.677–85.
2 Finberg, p.177.
3 *Fragments of Family History written by Sir Augustus Wall Callcott R.A., a few years before his death in 1844*, collection of the late Lady Robinson.
4 *Ibid.*
5 *Ibid.*
6 J.E. Hodgson and F.A. Eaton, *The Royal Academy and its Members*, 1905, p.248.
7 *Family History*, loc.cit.
8 *Ibid.*
9 *Ibid.*
10 W. Hazlitt, *Conversations with James Northcote Esq., R.A.*, ed. F. Swinnerton, 1949, p.2.
11 Collection of the late Mr Maurice Whitelegge.
12 Constable to Fisher, 9 May 1823, in Leslie, p.101.
13 On Hoppner as an imitator of Gainsborough see J. Hayes, *The Drawings of Thomas Gainsborough*, 1970, pp.80–81.
14 Six drawings from the set, with the exception of Callcott's, are in the collection of Mr D.L.T. Oppé.
15 Farington, 24 October 1806.
16 Callcott to Barry, 15 October 1833. Royal Academy Library, Callcott Papers, CA/I.
17 Farington, 20 June 1805.
18 Callcott's *Journal*, 21 July 1805, collection of the late Mr Maurice Whitelegge.
19 *Ibid.*
20 Farington, 20 March 1805.
21 Draft letter from Callcott to Mr T. Bennett, 1799, collection of the late Mr Maurice Whitelegge.
22 'Portrait of Sir James Mackintosh M.P.'; see the Earl of Ilchester, *Chronicles of Holland House*, 1937, p.153, and K. Garlick, *A Catalogue of the Paintings, Drawings and Pastels of Sir Thomas Lawrence*, *Walpole Society*, XXXIX, 1960–62, p.138.
23 Callcott's 1805 *Journal*, loc.cit.
24 Callcott to Chantrey, letter bound in Allan Cunningham's own copy of his *Wilson, Gainsborough and Kneller*, Victoria and Albert Museum Library.
25 Farington, 13 April 1806.
26 *Ibid.*, 13 October 1815.
27 *Ibid.*, 4 May 1818.
28 Collection of the late Mrs Nancy Strode.
29 Farington, 13 October 1815.
30 Lady Holland to Miss Fox, in the Earl of Ilchester, *op.cit.*, pp.108–9.
31 Kestner to Maria Callcott, 25 July 1836, Victoria and Albert Museum Library, Eastlake MSS., 86 PP 14, IV 4.
32 *Ibid.*
33 Eastlake to Maria Callcott, 6 March 1829, Victoria and Albert Museum Library, Eastlake MSS., 86 PP 14 IV 5.
34 Maria Callcott's detailed journals of the honeymoon tour will be available in microfiche, edited by David Brown and Christopher Lloyd, Oxford Microform Publications, 1981.
35 Constable to Leslie, 6 September 1834, in Beckett, III, p.119.
36 Waagen 1838, I, pp.154–6.
37 Passavant II, p.61.
38 Redgrave, p.344.
39 *Ibid.*
40 B.R. Haydon, *Autobiography*, ed. T. Taylor, 1853, III, p.24.
41 *Ibid.*, II p.405.
42 Redgrave, p.343.
43 Maria Callcott, *Journal*, 1829, collection of the late Lady Robinson.
44 Redgrave, p.343.
45 *Vernon Gallery*, 1854, III, No.12.
46 Mr Manson reported in *The Art Union*, VII, 1845.
47 Victoria and Albert Museum Library, press cuttings, IV, p.1656.
48 Ruskin, 'Foregoing Principles' to *Modern Painters* I, in Cook and Wedderburn, III, pp.191–2.
49 Farington, 13 April 1812.

Callcott and Turner

Although the work of Callcott and Turner was frequently compared during their lifetimes, the contemporary literature is vague as to how well the artists knew each other personally; and more recently it may have come as a surprise that among all Turner's letters, as now collected by Dr Gage, there is only one short note to Callcott.[1] It is, however, certainly a note from one intimate to another, a mallard duck standing in for the Mallord in the signature, and sufficient evidence exists, from around 1806, for a nearly continuous chain of personal and professional contact between the two painters which may have made redundant any written communication between them, and have been taken so much for granted by their contemporaries that it hardly justified comment or reminiscence.

When late in life Callcott compiled what he called his 'Dictionary of Anecdotes', it was inevitable that he should include a lengthy passage about Turner. But even Callcott's memoir tells us nothing about Turner the man, nor about its author's relations with him; instead it is an account of Callcott's first sight of a Turner drawing, 'an upright drawing about 10 inches of a water mill', in a colourman's shop in Coventry Street. Callcott does, however, at least take the opportunity to give his most sustained judgment of Turner's work, which may provide a fitting introduction to this account of his friendship and professional links with Turner. Henceforth, Callcott writes,

> ... I became a devout admirer of J.M.W. Turner. His were among the very first works I rushed to on the opening days of the coming exhibitions and invariably have I kept to my faith and admiration for his talents up to this moment. Much as it is to be lamented that a species of perversity induces him to court public outrage, even the most extravagant of his late pranks is not without its charms or destitute of indications that might astonish if the feeling with which the scene had been conceived had been fully developed and the picture carried to completion. Those who now scoff would be supposed to admire and worship. But as long as there shall be such works as the Mercury and Herse in Sir John Swinburnes collection and the Storm in that of L. Francis Egerton, the Echo of Ld Egremont, the numerous drawings made for Walter Fawkes of Yorkshire and others too numerous to mention in this place Turner's name will deserve to stand in the same rank with the names of the highest in his department of art.[2]

Evidence exists for Callcott's close and enthusiastic study of Turner's

Academy exhibits at least as early as 1799, for among his papers is preserved the draft of a letter describing them to a fellow exhibitor, a Mr Bennet who, because of a mention of one of his own pictures, is identifiable as an artist from Woodstock who showed several farmyard scenes between 1796 and 1799. 'All his [Turner's] work is truly astonishing for one so young', writes Callcott, himself only twenty, and continues to describe the exhibits individually, being particularly generous in his praise for 'Harlech Castle, Twygwyn Ferry' – 'equal to anything I have seen' – and for Turner's watercolours; 'drawing', Callcott adds, 'he has brought nearly to the effect of oil painting'.[3]

The tone of Callcott's letter to Bennet makes it clear that he had never met him, so he must already have been known by repute as an admirer of Turner who could be relied upon to be familiar with his most recent work. Callcott had most probably met Turner by this time, and it may well have been Hoppner who had introduced him, since by 1798 Farington noticed a growing rapport between Hoppner and Turner.[4] But there is nothing to suggest that Turner and Callcott became close friends at this early date. It is true that Callcott was well acquainted with Girtin, to whose Sketching Club he belonged in 1801, but this would not necessarily have brought him into frequent contact with Turner; nor would his friendship with James Holworthy, to whom he described his Welsh tour of 1804, for although Holworthy and Turner were close later on, there is no evidence that they had yet met, and Callcott had most probably been introduced to Holworthy not by Turner, but by Holworthy's teacher John Glover, whom he must have known well since he gave Farington an account of his prices and teaching in 1805.[5] In fact, for the first four or five years of the nineteenth century, there is no basis for a sustained personal contact between Callcott and Turner, and their earliest mutual acquaintances of any significance seem to have been their patrons, for in 1805 Callcott sold works to Sir John Leicester and Edward, Viscount Lascelles, and had received a commission from a third northern patron of Turner's, Thomas Lister Parker.

When, the same year, Henry Thomson told Farington that 'Callcott will press hard upon Turner',[6] he meant in rivalry rather than in imitation, for despite his already acknowledged admiration for Turner's work, it was not until 1806 that Callcott exhibited any paintings which were specifically likened to Turner's. In the absence of any work by Turner in the 1805 Academy (he showed only at his own gallery that year), the lush picturesque manner of Callcott's 'Water Mill' (No.2) made a profound impression in its own right, and appealed as an attractive alternative to Turner's various landscape styles. Some

[23]

surviving fragments of Callcott's diary for 1805 offer valuable insights into the critical climate as it affected both artists that summer, and indicate that the association of Callcott with Turner began, not as the personal friendship or stylistic affinity it became later on, but as a campaign by certain critics and connoisseurs to promote Callcott into a rival who could oust Turner from his emerging supremacy in landscape. Callcott's friends, particularly Henry Thomson, associated this with the newly formed British Institution, and it can be no accident that a landscape exhibited by Callcott in 1805 was bought by Richard Payne Knight, champion of the picturesque and, with Sir George Beaumont, one of the Institution's leading directors; Sir John Leicester, who bought the 'Water Mill' that year, was another. During one discussion about the Institution that year, Callcott, Hoppner, Thomson and William Owen 'all seemed to agree it had the appearance rather of desiring to get the patronage into its own hands than to benefit the arts',[7] and on a second occasion the Institution's estimates of Callcott and Turner were specifically compared; 'T. [Thomson] told me he had been conversing with Opie further on the subject of the new institution, that he was himself of the opinion that the comitty was composed of such persons as would be biased, and appealed to me with openness whether I did not think they would endeavour to raise me at the expense of Turner. I acknowledged I thought such a disposition too evident – my reputation is assuredly too much owing to this'.[8]

But if the Institution thought it saw in Callcott a clever but pliable artist whose work could be manipulated to steal Turner's popular appeal, it was disappointed. After 1805, perhaps at least partly in defiance, Callcott's work began to show strong Turnerian characteristics which must soon be examined in more detail, and at the same time Callcott proved to be opposed to everything the Institution stood for. Although he sustained the friendship and admiration of one director, Sir Richard Colt Hoare, and received generous patronage from Sir John Leicester, he became an implacable enemy of Payne Knight, even, in 1818, threatening to resign his diploma if Knight were elected the Academy's Professor of Ancient Literature, and clashed vigorously with Beaumont both on aesthetic grounds, and over the role of the Institution *vis-à-vis* the practising artist and the Academy. In these arguments Callcott and Turner were wholly in agreement, and it must have been this common ground between them which first cemented their friendship. It was as a 'white painter' and a follower of Turner that Beaumont first attacked Callcott in 1806, and continued to castigate him for several years, but the root of the conflict was not really an aesthetic one; nor were Callcott and

Turner fundamentally concerned with the damage done to their reputations by Beaumont's barracking. It has been argued with some success by Martin Hardie, that the harm done to Turner by Beaumont was almost entirely a fabrication of Callcott's,[9] and it is true that Callcott made much of this to Farington; but, in 1811, he also observed to Farington that Turner was 'too strong to be materially hurt' by Beaumont's attacks,[10] and these were not the real substance of his complaint. Rather he objected to the threat posed by the Institution to the traditional supremacy of the Academy and to the stylistic freedom of living artists, themes which run through all his recorded comments about Beaumont. Significantly, Callcott's feelings about the Institution came to a head in April 1813, at the very time that his quarrel with Beaumont really emerged into the open. On 8 April, he told Farington that 'the active Directors of the British Institution will gradually assume a controuling power over Artists, and should they obtain the application of any fund granted by the Government for promoting the Arts, will oust the importance of the Royal Academy'.[11] Turner was no less jealous of the Academy's autonomy, and the previous December he had joined with Callcott and Robert Smirke in opposing the Institution's plan to hold an exhibition of works by Reynolds at the same time as the 1813 Academy show.[12]

It was in 1813 that Callcott decided not to exhibit at the Academy, the cause, as James Ward reported to Farington, being that he was 'mortified by the continuing criticism of those who cry out against "the White Painters" as they call them'.[13] This clearly referred to Beaumont, who had repeatedly used the term of Turner and Callcott since 1806, and a few days later Callcott himself told Farington that he thought it 'prudent' not to exhibit, and that Sir George's 'persevering abuse of His pictures had done him harm . . . He said Turner has also suffered from the same cause, and had not sold a picture in the Exhibition for some time past. Turner called upon Calcott at Kensington a while since and then said that He did not mean to exhibit from the same cause that prevented Calcott, but He has since altered His mind and determined not to give way before Sir George's remarks. Calcott said He had no objection to its being mentioned that He forebore from exhibiting from the cause here assigned'.[14] After this conversation Farington attempted to mediate. Beaumont told him that he 'personally liked Calcott, but did not approve His manner of colouring His pictures, nor His imitating Turner; indeed, there was no way of knowing the pictures of one from those of the other';[15] he did bow to Callcott in the Academy having cut him for some time,[16] but Callcott was more put out than mollified, and, diverted from

his direct personal attacks on Beaumont, fell back on his critique of the Institution, complaining that its directors were not 'patrons of Artists but breeders of Artists', presiding over 'a nursery for such a purpose';[17] and, in 1814, when he again declined to exhibit, he was still watchful for any developments which 'tended to add to the power & influence of the Governors of the British Institution, who might eventually look to establish an authority over the Body of Artists'.[18] This was the crux of Callcott's antagonism towards Beaumont, and the 'holy war' against Turner of which he made so much was probably a stratagem to whip up dislike of a man who represented a far wider threat.

Callcott's prominent place in the saga of Beaumont's feud with Turner and the 'white painters' has led to the suggestion that he had a hand in writing the *Catalogues Raisonnés of the Pictures now Exhibiting at the British Institution*, of 1815 and 1816, publications which, as well as attacking the Institution's directors and their preference for the old masters above living artists, were by implication a defence of Turner – 'the first genius of the day' – and his circle. A bound set of Institution catalogues formerly in the possession of John Sheepshanks includes both these pamphlets, on one of which is a pencil note in Sheepshanks's hand, 'By Sir A.W. Callcott, R.A., & Thomson R.A.'.[19] Finberg, who first published this, remarked quite rightly that as Callcott was knighted in 1837, the attribution must have been recorded at or after that date, when there would have been no risk in revealing the old secret, and as a number of the Sheepshanks catalogues and other papers had once belonged to Callcott himself, Finberg was 'inclined to attach some importance' to the ascription, adding that Walter Fawkes, himself said by Thomson to be the author, may have contributed to the printing costs.[20] It may be significant that Callcott's was the one name that was not suspected at the time; had the Institution's directors thought of him they would hardly have attempted, as they did, to purchase his 'Passage and Luggage Boats' from the Academy in 1815, as a gesture of reconciliation and also as part of their new policy of acquiring major modern pictures which had prompted their purchase of Wilkie's 'Distraining for Rent' the same year. Callcott himself told Farington that during visits to Earl Grey and Sir John Swinburne, 'He saw the "Catalogues Raisonnes" . . . He thought it was acceptably received though rather coarse'.[21] This might be a disclaimer or a smokescreen, and there seems no reason to attach any more or less significance to it than to the conflicting attributions mentioned by Farington and the Redgraves; while the prose style of the *Catalogues* is certainly not Callcott's, Beaumont was probably correct in thinking that they were 'not written by one person only but by four or

five',[22] and the views expressed in them are precisely those held by Callcott, Hoppner, Thomson and Owen, and can be found first in Callcott's diary for 1805. Nevertheless, it seems unlikely that an artist who had so high a regard for the Dutch masters could, for whatever reason, write a mockery of at least the first of the two catalogued exhibitions, which was devoted to their work. Moreover, in 1815 Callcott so far modified his anger as to resume exhibiting at the Academy with 'Passage and Luggage Boats', a work apparently modelled on Cuyp and doubtless designed to show that a contemporary British artist could match the old masters whose work was then hanging at the Institution. Callcott must have decided that actions spoke louder than words, a healthy state of mind inconsistent with the rather shrill tone of the *Catalogues*. I do not believe Callcott was their author or even their main inspiration, but that his own ideas contributed to them seems probable.

During the years when they were under attack from Sir George Beaumont, Callcott and Turner had drawn very close as friends and colleagues. In 1809 Callcott was the first to confide to Farington that 'A Mrs. Danby, widow of a Musician' was living with Turner,[23] and, as Mr Lindsay has suggested, he may have introduced her to Turner since her husband had been, like Callcott's brother John, a popular glee composer and organist.[24] Callcott was also privy to Turner's business concerns, for in 1811 he reported to Farington Turner's pricing policy for pictures exhibited at his own gallery.[25] But it was within the Academy, whose prerogatives they both valued so highly, that the two artists were brought closest together. In 1806 Turner supported Callcott's election as Associate, and in 1810 as full Academician. In 1811 they served together on the hanging committee, were both elected Visitors to the life schools, and, with Farington and Henry Howard, laid out the table plans for the Academy dinner. At Council meetings they began to work as a team, one proposing and the other seconding important motions,[26] and in 1811 Turner supported Callcott when he drafted a 'Memorial' to the Prince Regent opposing the admission of engravers to the Academy. By 1815, when both artists were among the Visitors elected to the new Schools of Painting,[27] Callcott was firmly established as Turner's henchman, and was on equal terms with his patrons; at that year's Academy dinner, he sat with Turner and their fellow painter James Ward, and with Walter Fawkes, Sir John Swinburne and Thomas Lister Parker, at a small but conspicuous table jutting out into the centre of the room.[28]

Their friendship was probably never closer than it was at that time. From 1816, Callcott was kept increasingly busy on his series of large marines and other commissioned pictures, and although these took him

as near as he ever came to Turner's work, they left him little time for social contact. Perhaps their travels in connection with their work provided Callcott and Turner with their main interests in common before 1827, when Callcott married Turner's acquaintance Maria Graham. In the late summer of 1818, for instance, Callcott was in Rotterdam, belatedly to gather material for his picture (No.17) commissioned two years earlier by Earl Grey, while Turner had been there the autumn before, at the end of a longer tour of the Rhine and the Netherlands; and in May, 1819, Callcott visited Scotland to make drawings for Scott's 'Provincial Antiquities', his earliest task of any magnitude for the engraver and the first on which he collaborated with Turner, who had made his own studies in Scotland the previous year and may well have provided Callcott with introductions in Edinburgh. Links would have continued to come through mutual patrons such as Sir John Swinburne and Lord Egremont, and, in 1827, Callcott's marriage would further have endeared him to Turner, who described Maria Graham in a letter to Holworthy as 'a very agreeable Blue Stocking'.[29] Turner had met her in Rome in 1819, during his first visit to Italy, when she was living at 12 Piazza Mignanelli with her first husband and playing hostess to Charles Eastlake. Turner's own trip to Italy must have been in both Callcotts' minds when they set out on their honeymoon in 1827, while Turner, on his way back to Rome in 1829, wrote warmly of Maria to Eastlake, with whom he was to stay in the city;[30] and later, Eastlake was able to keep the Callcotts informed about Turner's work in Rome on pictures including 'Regulus' and the 'View of Orvieto' (Tate Gallery).[31] One may well imagine that when they were all reunited in London, Turner and the Callcotts had many travel experiences to share; did, for instance, an account by the Callcotts of their visit to Leo von Klenze's Walhalla near Ratisbon encourage Turner to see it on his way back from Venice in 1840, and thus provide an early inspiration for his 'Opening of the Walhalla' of 1843 (Tate Gallery)? Nevertheless, Callcott's marriage seems to have marked a turning point in his relationship with Turner. Apart from cooperating on two further projects for the engraver, illustrations to Samuel Rogers's *Poems* and Finden's *Bible*, the two men probably saw rather less of each other than they had earlier. Callcott's social life during the 1830s was centred mainly on the great aristocratic town houses – never Turner's chosen milieu – and on his wife's own salon; artist friends now usually came to Kensington, and there is no evidence that Turner was often among them.

* * *

Callcott's stylistic links with Turner, like his personal ones, were closest in earlier years. His assessment of Turner in his 'Dictionary of Anecdotes' leaves no doubt of his difficulties in appreciating the artist's later work, and Sir George Beaumont could never have repeated, during the 1830s, a remark such as that which Farington reported in 1812, that Callcott 'is merely a follower of Turner and seems to look at nothing else'.[32] Even at that time, however, Callcott had been far from exclusively an imitator of Turner, and in so far as his work did reflect Turner's influence, it has to be set into the context of attitudes towards copies and pastiches wholly different from those prevalent today. Distinguished artists, past or present, were expected to attract imitation or reinterpretation. Turner himself, in his tributes and challenges to Claude, Cuyp, Rembrandt and Watteau, worked within this eclectic convention, and as a painter enjoying almost the status of an old master in his own lifetime, might be thought as deserving of imitation as they. Callcott was not the only artist to model himself upon him; Northcote, noticing the Turnerian manner of his 1806 'Calm' (No.4), could already add that it was one which 'several others had adopted',[33] while William Havell and William Daniell were observed as almost obsessive in their study of Turner's work;[34] later, J.B. Pyne was to take over where Callcott left off in drawing inspiration from it. Nor was Turner the only British artist to become the subject of an imitative trend; Gainsborough is a prime example, and an apposite one as his drawings were pastiched by Hoppner and Callcott himself, as well as by Rowlandson and others; and lesser, and less individual, artists were similarly honoured, notably Sir Francis Bourgeois, a friend of Turner and himself a conspicuous imitator. In 1803 Constable could write of the Academy exhibition, 'I saw, as I thought, a great many pictures by Sir F. Bourgeois, but it proved that not half of them belonged to him, but to another painter who had imitated his manner exactly. Sir Francis was the hangman, and was so flattered by these imitations that he has given them as good places as his own'[35] – an anecdote which interestingly prefigures Callcott's moving his 'Mouth of the Tyne' in the 1818 exhibition to make way for Turner's 'Dort', which paid obvious tribute to his own 1816 'Pool of London' (No.15).

The case of the 'Dort' should alone warn us against thinking of the Turner/Callcott relationship as wholly one-sided. Direct derivations from Turner certainly occur from time to time in Callcott's production, beginning with the two coast scenes shown in 1806 (Nos 3 and 4) which, as Beaumont soon recognised, owed much to Turner in composition and handling. Turnerian also were two pictures exhibited in 1811, 'Southampton from Weston Grove' (No.11) and 'Itchen Ferry' (No.12);

fig.1

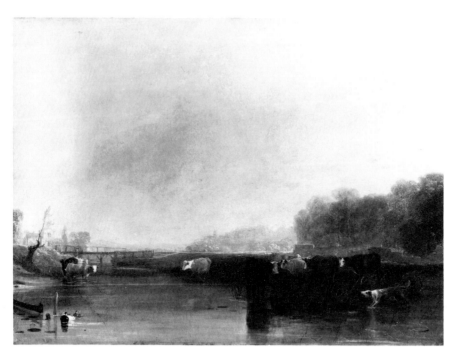

features such as the softly rounded treatment of the trees in the former, and the subjugation of solid forms to light and atmosphere in the latter show a more penetrating awareness of Turner's work. Specific sources might be cited for these paintings – 'Calais Pier' (National Gallery) for the cold blue/green waves striated with white foam in the 1806 'Sea Coast with Figures bargaining for Fish', 'London from Greenwich' (Tate Gallery) for the panoramic composition of 'Southampton', 'The Sun rising through Vapour' (National Gallery) for the refulgent colour of 'Itchen Ferry' – but in none of these cases can Beaumont's complaint that 'there was no way of knowing the pictures of one from those of the other'[36] be really justified. Apart from the direct replica Callcott painted of Turner's Washington 'Junction of the Thames and the Medway' (see No.7), the 'Morning' shown at the Academy in 1811 (Victoria and Albert Museum; fig.1) is unique in reproducing almost exactly (in reverse) a Turner composition, the 'Union of the Thames and the Isis' (Tate Gallery; fig.2) shown in Turner's gallery two years earlier. Callcott was in fact far from an uncritical or passive copyist of his friend's work; both artists were prepared to learn or borrow from each other, and this reciprocity is apparent if we examine just three aspects of their early work, their mutual interests in the picturesque, in colour and tonal effect, and in historic landscape.

Thanks mainly to Dr Gage, the impact of the picturesque on Turner's

fig.2

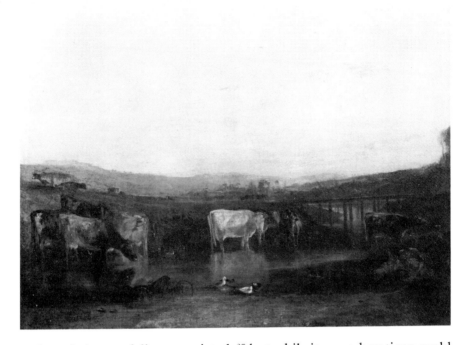

early style is now fully appreciated;[37] but while its reverberations could still be felt up to around 1809, when he showed in his gallery the 'Sketch of a Bank with Gypsies' (Tate Gallery) with its picturesque vocabulary and Rembrandtesque chiaroscuro, the main trends in Turner's landscape work were by now towards the sublime, or to a naturalistic pastoral mode. For Callcott the picturesque remained a more fundamental source, itself capable of considerable variety. His large 'Market Day' exhibited in 1807 (No.5) had been an exhibition machine in standard picturesque taste, full of contrasts in lighting and landscape texture; his 1811 diploma picture, 'Morning' (No.10), was also a picturesque essay, with genre figures in the manner of Ostade; and his 'Travelling Tinkers' shown the same year (Osborne House), a work probably suggested by Turner's 1809 'Sketch', was still typical of the tradition. Its main features – the gypsies themselves, their setting of a rugged hollow of ground, slanted trees, broken fence posts – were more central to Callcott's work than they now were to Turner's; it would have been Callcott's own interests as a landscapist which made him particularly responsive to Turner's 1809 picture and encouraged him in what may have been a specific quotation.

'Travelling Tinkers' was not, however, really characteristic of Callcott any more than the 'Sketch' was of Turner, and Callcott's own treatment of the picturesque is best seen in an un-Turnerian work like the 1805

'Water Mill' (No.2) in which the convention is transformed into an elegiac pastoralism wholly lacking the 'rough' quality of the true picturesque and if anything even less naturalistic. Very early water-colours of mill scenes by Turner such as the 'Marford Mill' (National Museum of Wales; fig.13, p.52) together with the fancy pictures of Gainsborough, Wheatley and Henry Thomson, the landscapes of Ruysdael and other Dutch masters, and the lyrical pastorals of Boucher, contribute to an eclectic style in which the picturesque acquires an almost classic feeling of the ideal, and a mood of luxury and reassurance. If Turner, with the occasional exception to prove his variety, was moving away from the picturesque, Callcott was adding new force and sentiment to it, and perhaps the clearest insight into his purpose may be gained from a remark among his notes that 'our taste has a kind of sensuality about it as well as a love of the sublime. Both of these qualities of the mind are to have their proper consequence as far as they do not counter-act each other, for that is the great error which much care must be take to avoid.'[38]

There can be little doubt that Turner looked hard at the 'Water Mill' – one of the most talked-about exhibits of 1805 – and his own re-examination of picturesque values may well have been encouraged by it. In the light of such a highly contrived picture, Turner's marginalia to Shee's *Elements of Art*,[39] recognising that standard picturesque features could, if treated on their own, amount to no more than 'common pastoral', gain a particular significance (and the probable impact of Callcott's painting and others in a similar vein exhibited during the next few years, might be an argument for dating the annotations near Shee's original publication year, 1809, rather than to after 1818 as Dr Gage later suggested[40]). The plate of 'Pembury Mill' from the *Liber Studiorum* (fig.15, p.55) presents the ingredients of Callcott's 'Water Mill' – the cart, doves, ducks, lap-boarding – in close up and in a functional situation, corresponding to a 'common pastoral' category; Callcott's picture, on the other hand, anticipates the 'epic' or 'elevated' pastoral type of the 'Liber', and perhaps even the monumentality of 'Crossing the Brook' (Tate Gallery).

'Crossing the Brook', as Sir George Beaumont complained, is very pale in colour, and in this respect it may not be too far-fetched to link it with Callcott's work. When Thornbury went so far as to say, of Turner's 1810 'Abingdon, Morning' or 'Dorchester Mead' (Tate Gallery; fig.3), that 'the style is after Calcott',[41] he would have meant not only the refined rustic subject matter but also the effect of bland, suffusing light, achieved through finely modulated tones. It would be foolish to claim that Callcott

could stand in the same league as Turner either as a theorist or
practitioner in matters of colour, but, like Turner, he had been brought
up in an atmosphere seething with colouristic nostrums and recipes, and
among his notes are many concerned with colour problems which show
that he shared the contemporary fascination for the subject. Callcott had
much in common with Turner as a colourist, and in this respect he was
far from being merely a copyist; indeed he was regarded in his lifetime as
something of an innovator in his use of colour. Today, without recourse
to all the relevant paintings, this is bound to raise an eyebrow, but the
evidence suggests that Callcott reached an understanding of what was
then termed 'aerial perspective', of the effect of atmosphere and distance
on form, and developed an associated colouristic programme which
involved working upwards from the lightest tones and downwards from
the darkest, independently of Turner's influence. As the Redgraves put
it, Callcott 'early became aware that with the limited scale of light and
shade, of colour and negation, at the command of a painter, as compared
with that of nature, a compromise must absolutely be made, and he
adopted the principle of reducing the positive tints of his pictures to
negative ones, diffusing light pretty generally throughout the whole, and
making the figures . . . the telling points of the composition'.[42] This
process must have been what Sir Richard Colt Hoare had in mind when

fig.3

he praised Callcott's 'own original style of colouring',[43] and it is seen clearly in the 'Mill near Corwen' (No.9) painted for him *c*.1808, a work with many affinities with Turner in his pastoral mood; here, as in Turner's English landscapes of around the same date, an unpicturesque pale colour and light is applied to traditional picturesque features, and this, in part at least, was Beaumont's complaint when he linked the two artists as 'white painters'. The practice described by the Redgraves had first appeared in Callcott's 1806 'Calm' (No.4), one of the pictures which first attracted Sir George's attacks; it must also have been apparent in the 'River Scene' exhibited in 1808 which, according to its catalogue description when it was sold by Sir John Leicester in 1827, showed 'the effect of vapour of a sultry sun'; and it was carried furthest in 'Cow Boys' (No.6), presumably the work shown in 1807 which Henry Thomson compared favourably to Turner's 'Sun rising through Vapour'. The three last paintings were in Sir John Leicester's collection at various times and would have been well known to Turner.

It will be recalled that Callcott had named 'a love of the sublime' among the features of contemporary taste, and by 1817, when John Glover showed at the British Institution his 'Landscape Composition', painted three years earlier, between a Claude and a Poussin, at least one reviewer placed Callcott with Turner as the finer painters of historic landscape. This estimate would have been based on the several compositions he produced between *c*.1809 and 1814, which, in style and subject matter, were closely related to Turner's work in the same vein.

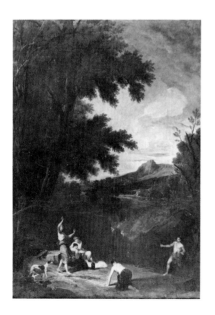 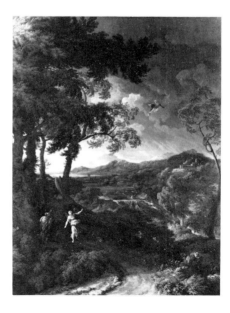

left fig.4
right fig.5

Callcott may have wished not to be outdone by Turner in the range and scale of his work; moreover in 1809–10 he was in the running for election as Academician, and probably felt it appropriate to prove himself in a more elevated and academic art. Thus, in 1810, he completed, with his friend William Owen who contributed the figures, a large 'Diana and Actaeon' (National Trust, Stourhead; fig.4) for the exhibition that year. A rugged quality in the landscape places the picture closer to Dughet than to Claude, and the former's upright 'Storm: Elijah and the Angel' (National Gallery; fig.5) probably provided the source for the composition. Intended as a major exhibition machine, 'Diana and Actaeon', according to Callcott's account to Farington, actually fell victim to Sir George Beaumont's strictures, and Lord Brownlow, who had been expected to purchase it, withdrew his claim; it was finally bought by Callcott's supporter in the British Institution, Sir Richard Colt Hoare. The strong blue and white sky recalls Veronese, and it can be no accident that in 1811, having neglected such subjects since showing the 'Goddess of Discord' in 1806, Turner exhibited three landscapes in the grand manner, one of which, the upright 'Mercury and Herse' (private collection), also draws on Veronese and was probably presented as a direct reply to 'Diana and Actaeon'. The same year Callcott also himself painted a 'Mercury and Herse', a 'large upright', for Mr Carey of Torre Abbey;[44] this is untraced today but the coincidence of subject can leave no doubt of its connection with Turner's picture.

A further link between Callcott and Turner as painters of historic landscape arose in 1811, for while Turner showed his 'Apollo and Python' (Tate Gallery), perhaps painted several years earlier, Callcott contributed an 'Apollo slaying the Sons of Niobe at the Altar of Latona, a Study'. Most reviewers were agreed in thinking Turner's 'Mercury and Herse' the finest landscape of the year, but Robert Hunt, writing in *The Examiner*, observed that Callcott was 'beginning to share with Mr. Turner the highest honours of the Art', and was indeed 'the best painter of figures of all our eminent landscape painters. Mr. Turner always gives the suitable action and character, but Mr. Callcott superadds to this, more carefulness of delineation'. Of his 'Apollo', Hunt continued, 'The sublime demands what is here given with a just but daring hand, – the clash of elements, the opposition of colours, of line, and of angular forms. The revengeful aspect of Apollo as he launches his destructive arrows, the bluster of the wind, and the contrast of gloom with the celestial blaze, – the flight of victims, the piteous prostration of the dead, the more pathetic deprecation and fears of the living who are doomed to death, and the contrast with all this of complacency and quiet in the statue of

Latona, before which the havoc and horror are displayed, exhibit a picture of the most terrific sublimity'.[45] Evidently Callcott had in mind Wilson's 'Destruction of Niobe's Children', and Hunt's review indicates that he had succeeded in attaining the sublime; Hunt's vocabulary also shows how it was possible to progress, as Callcott had done, to the sublime by way of the picturesque – and it is significant that the painting was a 'study', for as Fuseli had observed in his review of Uvedale Price's *Essay on the Picturesque*, sketches were more picturesque than finished works.[46]

Some of the most obvious similarities between Callcott and Turner occur in marines, coast and river scenes. Callcott's 1806 coast subjects (Nos 3 and 4) and the 1811 'Itchen Ferry' (No.12) were not the only such pictures to display Turner's influence. Early oil sketches from nature like 'Richmond Bridge' (No.8) or the so-called 'Fishing on the Mere' (Tate Gallery) may have been partly inspired by Turner's Thames oil studies; the latter picture, in its softly scumbled paint and rounded tree forms, may be compared with a Turner such as the Tate's 'Cliveden on Thames', which was possibly among the 'views on the Thames, crude blotches' that so disgusted Benjamin West in Turner's gallery in 1807.[47] Callcott must have made a special study of the Thames subjects shown there in the two following years, for their impact is clearly felt in some of his own marines painted after 1816; and it was almost certainly in 1807 that Turner had shown the 'Junction of the Thames and the Medway' (National Gallery of Art, Washington), of which Callcott was to paint a full-scale replica for its first owner, Thomas Lister Parker, probably working from oil sketches made from the original at Browsholme Hall in 1808, one of which may be identified with the picture here exhibited (No.7).[48]

Callcott's first very large marines, 'Passage and Luggage Boats' and 'The Entrance to the Pool of London' (No.15), shown in 1815 and 1816, were formed mainly on Cuyp, and the latter picture at least has a mood of its own quite distinct from anything in Turner's work up to that date. According to Thornbury, Turner once declared he would have awarded it a thousand guineas,[49] and 'The Pool' was manifestly a source for his own 'Dort Packet Boat from Rotterdam becalmed' (Yale Center; fig.18, p.79). Whatever the actual weather conditions Turner had experienced in Dordrecht in 1817, he may also have directed a more oblique reference to Callcott in the particular wording of his title. In 1816, following the success of his Cuyp-like 'Pool', Callcott had received Earl Grey's commission for a painting of Rotterdam; he had however delayed some time over it, and it was only in 1818, the year the 'Dort' was exhibited,

that he visited the port and began work. As the importer of a Cuyp-like style, Callcott could well have been the 'Dort packet boat', and its 'becalmed' condition may have mirrored his inactivity over the Grey picture; for someone as partial to word play as Turner, references to Dordrecht, Cuyp's native town, and to Rotterdam in the title of a work so clearly based on Callcott's 1816 painting, hardly seem accidental.

A strong element of competition underlay Callcott's and Turner's marine work, but they rarely struck so similar a chord as they did in 'The Pool' and the 'Dort'. The latter picture, in its brilliant colour and sense of expanded space, was after all a breakthrough for Turner, and the port and river scenes exhibited by the two painters in the following years reveal growing differences of approach. One reviewer, comparing Callcott's 'Mouth of the Tyne' (fig.6) with the 'Dort' in the 1818 Academy, wrote that 'MR. CALLCOTT has a powerful genius, and infinite command of his pencil; but he has none of the airiness or transparency of Vandervelde in his sea pieces. His colouring is heavy, dead and cold – his shadows are hovering and broken – and the waves in his pictures look solid. MR. TURNER on the other hand, is all air, sunshine, and transparency'.[50] This seems very perceptive today, but the general trend of contemporary criticism went in Callcott's favour. His sea ports, such as 'Rotterdam' (No.17) and 'Antwerp Quay' (No.19), would have stood in obvious comparison to Turner's treatment of such scenes in pictures like the 'Harbour at Dieppe' or the 'Cologne' of 1825 and 1826 (Frick Collection), which bathed their northern subjects in a southern light. Thus in 1819 Henry Crabb Robinson lamented the diminishing attractions of Turner's Academy exhibits including 'The Entrance to the Meuse' (Tate Gallery), but commended Callcott's 'grander' 'Rotterdam',[51] and in 1826 a reviewer condemned the 'intolerable yellow hue' pervading Turner's pictures while praising Callcott's sober 'Antwerp', adding 'It is astonishing to see under what various aspects different artists view nature. Here we have, in Mr. Callcott, the cool fresh breeze of European scenery, while in Mr. Turner's pictures we are in a region which exists in no quarter of the universe'.[52]

Turner was well aware of these criticisms, and indeed sent (without comment) a copy of the latter review to Robert Balmanno;[53] but he was not immune to the individual qualities of Callcott's marines, and would have made a particular study of the English subjects among them since he was, by the early 1820s, at work on his own drawings for 'The Rivers' and 'The Ports of England'. These highly finished watercolours, mainly drawn c.1824 and almost all in the British Museum, in fact present far closer analogies with Callcott's pictures than Turner's exhibited oils of

fig.6

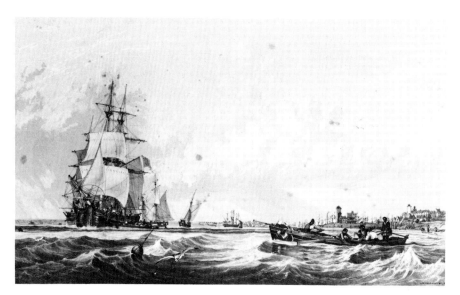

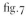

fig.7

the same period. Thus the 'Rochester on the Medway'[54] is likely to have been drawn in the same year as Callcott exhibited his 'Rochester, from the River, below the Bridge', the composition and effect of which, as preserved in a watercolour copy by Callcott's friend Dr William Crotch,[55] is very close to Turner's drawing. Turner's more open views of 'The Medway'[56] and 'Stangate Creek on the Medway'[57] echo the spacious arrangement of Callcott's earlier 'Dead Calm on the Medway, with small Craft dropping down on the Turn of the Tide; Sheerness in

the Distance' (private collection), shown in 1820. Callcott's 1818 'Mouth of the Tyne', as recorded in Dibdin's lithograph (fig.6), could well have suggested the composition of Turner's 'Portsmouth'[58] (fig.7). Finally, Callcott's 1821, 'Dover from the Sea; a squally Day; Wind against the Tide', known from George Cooke's engraving, could have served partly for Turner's own 'Dover from the Sea' (Museum of Fine Arts, Boston) drawn the following year and unconnected with 'The Ports' series,[59] and for the later drawing which was included in it.[60]

If Turner had intended an implicit reference to Callcott in the title as well as the treatment of the 'Dort', he alluded to him explicitly in his oil, '"Now for the Painter", (Rope), Passengers going on Board' (City Art Gallery, Manchester; fig.8), shown in 1827. The previous year, following Clarkson Stanfield's failure to complete his 'Throwing the Painter' in time to make his Academy debut, Callcott had exhibited a marine entitled 'Dutch Fishing Boats running foul in the endeavour to board, and missing the Painter Rope' (whereabouts unknown; fig.9). The picture had been commissioned by Jesse Watts Russell, and the topical twist to its title must have been a last-minute addition; it makes no reference to Stanfield's own marine style, as yet hardly formed, and of all Callcott's marines it is one of the most obviously based on Turner, following in reverse the '"Leader" Seapiece', probably from the

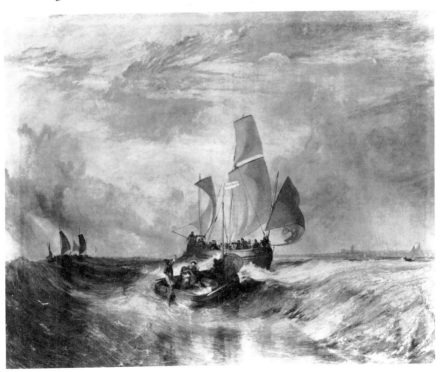

fig.8

mezzotint in the *Liber Studiorum* (fig. 10). Recognition of this, as much as any wish to join in the fun at Stanfield's expense, must have accounted for Turner's continuation of the joke in 'Now for the Painter'. At the same time Turner probably took the opportunity to emphasise how far his own marine art had advanced upon the earlier, simple and horizontal

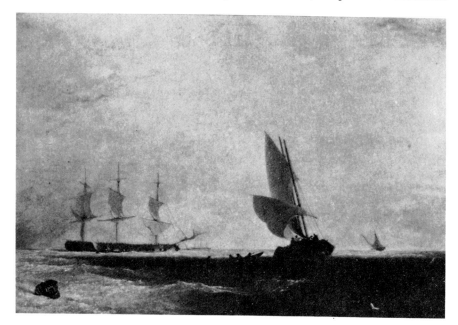

fig. 9

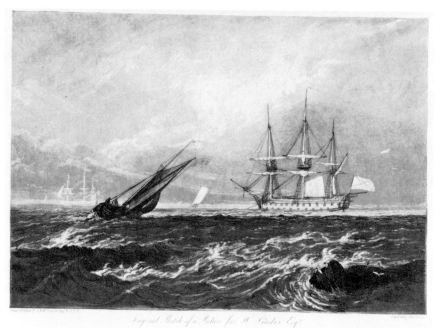

fig. 10

composition followed by Callcott; his 1827 painting, with its swirling movement and translucent colour, is in his most up-to-date manner, and this would have been all the more apparent since the influence of Turner's early marines was also paramount in one of Callcott's own Academy exhibits of the same year, 'Heavy Weather coming on, with Vessels running to Port' painted for Lord Egremont (Petworth House). Patron and painter must have intended this picture to complement Turner's 'Egremont' seapiece, 'Ships bearing up for Anchorage' of 1802 (also at Petworth), which is only very slightly larger. Both paintings do indeed hang well together, and Callcott could again have referred conveniently to a *Liber* plate for the Turner; his most direct source, however, appears to lie in the 'Bridgewater' seapiece, 'Dutch Boats in a Gale' (private collection), which Turner had shown in 1801; the large fishing vessel which dominates Callcott's subject is quoted almost verbatim from the Bridgewater picture, as is his effect of stormy cloud coming up from the left, while a distant frigate has simply been moved from left to right. Only in its thin and liquid paint does 'Heavy Weather' approach Turner's work of its own date; in other respects it looks back to the Turner of twenty five years earlier.

The Italian subjects Callcott showed at the Academy following his return from his honeymoon in 1828 are the last of his pictures to show any affinities with Turner. But differences are as readily perceptible. Callcott's tendency towards generalised titles – 'recollections' or 'compositions' from 'materials' at Rome or Baiae – show his intention to evoke the spirit and history of Italy in a synoptic manner, demonstrating his own classical learning and flattering that of his patrons; pictures such as the 1842 'Italian Evening' (Harrogate Art Gallery) are arrangements in strict Claudian taste, their only real impact coming from a deliberate contrast between old and new; as *The Art Union* wrote of the Harrogate example, Callcott offered 'the mingling of ancient and modern history; the crushed and fallen diadem of old Italia is at our feet, in contrast with the *alla giornata*, the perking tile-covered houses of modern Italy'.[61] Yet this contrast is neither as pointed nor as subtly achieved as it is in Turner's pairs of paintings of 1838 and 1839, and Callcott's Italian subjects totally lack the opulence and rich colour of Turner's. Nevertheless, their similarity of subject can be striking, leaving no doubt that the two artists were still paying close attention to each other's work.

Callcott's first exhibited Italian subject, 'The Fountain; Morning' painted for Lady Swinburne, was also the first to which he appended a quotation, probably inspired by Turner's regular extracts from *The Fallacies of Hope* and other sources, although in this case the tag was

provided by Maria Callcott and Sir John Swinburne, who as the former wrote, 'recommends the same bit of Horace I had thought of, namely the beginning of the Ode to the Fountain Digentia'.[62] The painting, which may be identified with a now somewhat depressing canvas at Sudley, Liverpool,[63] was much admired at the Academy in 1829; Lawrence, guiding a party round the exhibition, singled it out, with Wilkie's contributions including 'The Pifferari' bought by George IV, for special praise, while Maria, having confided to her diary her views on Turner's exhibits – 'Polyphemus a delicious dream. Loretto spoilt by a tree'[64] – added that 'the thing that attracted most notice seemed to be the Fountain of our own – Everybody liked that'.[65] Though Turner's associated quotation came from James Thomson instead of Horace, his own 'Fountain of Indolence' shown in 1834 (loaned to the Beaverbrook Art Gallery, Fredericton, New Brunswick), may have been partly an answer to Callcott's popular work.

Callcott and Turner had been specifically linked as painters of Italian landscape as early as 1829, by Sir John Soane, who was already the owner of two paintings by Callcott and a longstanding friend of Turner. The year before, Soane had paid Turner £500 for a picture, presumably the 'Forum Romanum, for Mr. Soane's Museum' (Tate Gallery; fig.11), which had actually been exhibited in 1826; he did not, however, take possession, and at a dinner party in 1829 he handed Callcott 'a strange letter' enclosing his commission for another Italian composition, together with the same sum of money.[66] It has been suggested that Soane rejected Turner's painting because it was too large for the restricted space available in his gallery,[67] but if this were so he would hardly have ordered another very large canvas from Callcott so soon afterwards – indeed Callcott's completed picture, 'The Passage Point' exhibited in 1830 (fig.12), is actually considerably larger than the Turner, and one of the largest in the Soane Museum. Soane's change of course seems all the more surprising as the 'Forum Romanum', with its accurate record of the monuments of ancient Rome, might be expected to have appealed to his antiquarian tastes, whereas Callcott, in 1829, had hardly proved himself at all as a painter of Italian scenes. One can only infer that Turner's painting offended Soane on stylistic grounds. As his Museum was indeed confined he may have found the colour of the Turner too powerful and assertive, and decided that a placid lake scene such as Callcott provided for him would offer greater relief. The 'Passage Point' is open in composition, as well as cool and sweet in tone, has none of the inward tension of Turner's 'Forum', and suggests the effect of a window thrown open on a clear day when the panelling behind which it hangs is unfolded.

fig.11

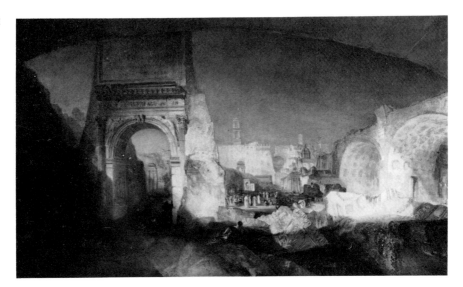

fig.12

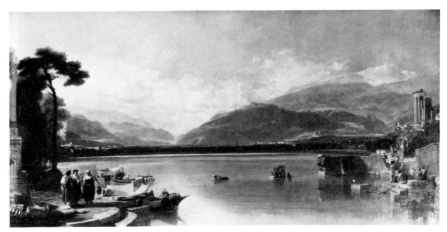

Among the most effective passages in the Soane picture are the Alpine peaks in the distance, and despite his early uncertainty in Wales, Callcott responded appreciatively to Italian mountain scenery, and showed in such subjects a heightened awareness of particular conditions of weather and light. A 'Scene suggested by an Effect seen after heavy Rain in the Ligurian Mountains near Sarzana', painted for Lord Durham and exhibited in 1832, was, as its title implies, naturalistic in intention, and seems from an old photograph to have been a most impressive view of a mountain valley, with a distinct memory of Turner's 1803 'Bonneville' (Yale Center). To stress the inspirational qualities of the Alpine scenery, Callcott showed the picture with the underline 'Why to yon mountains turns the musing eye?', and a more overtly religious theme appeared in another lost exhibit of 1832, a 'Finished Sketch of Italian Girls going in

Procession to their first Communion, painted in consequence of seeing a single Sun-beam fall on the High Altar'. A third picture shown that year, 'The Ruined Tomb' painted for Lord de Dunstanville, was also designed to evoke a powerful vein of sentiment through the symbolism of light. The subject, a sarcophagus of the kind found in the campagna, suggested the old theme of *Et in Arcadia Ego*, but Callcott's friend William Hallam proposed an alternative Greek inscription for the tomb, which translated read 'Tombs are corruptible', and the artist himself contributed blank verse for the frame:

> What though the monuments of men decay,
> And mingling with the ashes they contain,
> Destroy the fame they should preserve – what though
> In seeming scorn of human worth, Nature
> Alike, unmindful of the dead, scatters
> Her blooming sweets, and casts her cheerful beams,
> Around the ruins of the tomb – those sweets,
> Those beams, which even through the tomb she sheds,
> Are thou who live, are fraught with heavenly light
> And love, pointing man's hopes to brighter realms
> To sun's eternals blazing round that throne,
> Where bending to his God, man triumphs o'er the Grave.[68]

Paintings like the three just mentioned may, in their literary allusion or attempt to convey the mystical power of natural effects, have owed something to Turner's treatment of light, and the cadences, if not the enhancing sentiments, of Callcott's one recorded piece of poetry, echo the *Fallacies of Hope*. On the other hand Turner himself may have been inspired by the Wilsonian 'Cicero's Tomb near Mola di Gaeta' (London art market, 1972), which Callcott showed in 1838, to produce his own 'Cicero at his Villa' (Ascott) the following year. But the two paintings forcibly illustrate the contrast between the artists' approaches to Italy – Callcott's a fairly conventional exercise in classic nostalgia, Turner's vividly imaginative. And a similarly adverse contrast is apparent from Callcott's final direct inspiration from Turner, a rather stiff and pompous upright 'Procession to the Temple of Aesculapius' (Towneley Hall, Burnley) painted in 1839 as an attempt to rival Turner's 'Phryne going to the Public Baths as Venus' (Tate Gallery) exhibited the previous year.

Although no stylistic affinities arose from them, the closest contacts between Callcott and Turner in the 1830s probably came in the course of their work for the engraver. Following their collaboration over Scott's *Provincial Antiquities of Scotland*, they worked again on illustrations to Samuel Rogers's *Poems* and Finden's edition of the Bible. For the latter,

Turner told the Revd William Kingsley that 'he and Callcott had a certain number of the Bible sketches to realise between them: they agreed to pick them alternately, drawing lots for first choice. Callcott won the choice and selected at once a sketch of Ararat'.[69] Both projects brought out the worst in Callcott's character. He disliked Rogers, to whom he referred on occasion as 'Mr. von Dug Up', and an anonymous note among the Whitley papers records that whereas 'Rogers said Turner and Stothard entered into his views without difficulty in the illustrations of his Italy and Poems . . . Calcott wrote angry letters to him on his suggestions and alterations', and in the margin appears what is no doubt an extract from one of them – 'Don't send a copy of your book to Lady Callcott, I shall send it back'.[70] Callcott proved no less prickly over the Bible illustrations, which should have been straightforward as they were based on drawings by other artists and travellers, notably Charles Barry. But from a letter Callcott wrote to Barry in 1833, it is apparent that the Findens had expected more from him than he had contracted to give, and had then complained of the results. Callcott further implies, perhaps in contradiction of Kingsley's account, that he had intended only to correct the proofs of engravings from drawings by other hands, and not to make drawings himself; and, more interestingly, he protests about being 'offended on finding I had been called upon to take what Mr. Turner had relinquished', and being 'offered degrading terms' to do so.[71] We may well infer that Callcott had already, for some members of the art world, fallen behind Turner in status, and that he was both aware and resentful of it; again, his feelings may have become more pointed as he began to believe that Turner's own art was moving in the wrong direction.

Nevertheless it was Callcott who, during the 1830s, won the greater worldly honours and found the most critical favour. Although *The Spectator* observed in 1834 that 'Callcott's colours look opaque and heavy, and Turner's painting unsubstantial and visionary',[72] more typical were *The Morning Post*, which in 1831 urged Turner to study him as 'a model of purity and truth in landscape',[73] or *The Times* which commented in 1836 that to 'look at Callcott's "Trent in the Tyrol" after a dose of Turner's "Mercury and Argus" is as cool and refreshing as iced champagne after mulligatawny'.[74] Indeed, such comparisons persisted further into the century even in respect of Turner's early work, for in 1860 Ruskin was horrified to find on sale outside the National Gallery an unofficial pamphlet catalogue, in which Callcott's work was still preferred for its colour to 'The Sun rising through Vapour',[75] just as it had been by Henry Thomson in 1807. But whichever painter was

favoured, it is not without interest that contemporary criticism so often compared them as colourists, or stressed their treatment of atmosphere, for although their later work differed dramatically, these had been among the most significant interests Callcott and Turner had in common in earlier years. In Mrs Jameson's eyes, both artists ranked equal in this regard; complaining of the Germans that even 'their most beautiful landscapes want atmosphere', she declared that 'Not only have they no landscape painters who can compare with Callcott and Turner, but they do not appear to have *imagined* the kind of excellence achieved by these wonderful artists'.[76]

During the 1830s Callcott and Turner drew somewhat apart artistically as well as personally. Callcott's numerous pastoral English landscapes and Low Countries subjects of the decade find no counterparts in Turner's work, and actually have distressingly more in common with contemporary continental pasticheurs of the seventeenth century like the Koekkoek family, or with young English painters like William Shayer. Callcott was obviously puzzled and alienated by Turner's 'late pranks', and at varnishing day in 1835, when Turner was working on 'The Burning of the House of Lords and Commons' (Philadelphia Museum of Art), he appears in an anecdote by E.V. Rippingille as a bemused onlooker rather than an intimate who was privy to Turner's mind and methods. When Rippingille asked 'What is that he is plastering his picture with?', Callcott replied 'I should be sorry to be the man to ask him'.[77] Nevertheless he continued publicly to profess fervent admiration for Turner's work, and during one visit to a collection he was reported by a Miss Matilda Y. in *The Artist and Amateur's Magazine* in 1843, as making 'the most obvious distinction in his preference and admiration of the works of Turner, speaking of them as instances of a beautiful and profoundly truthful representation of nature'.[78] There can be little doubt that Turner knew of, and valued, Callcott's loyalty, and although he contrived for him no elegy such as he painted for Wilkie or Lawrence, he was deeply distressed by Callcott's death. Mr Hammersley, calling on Turner on 26 November 1844, found him restless and taciturn, and clutching a letter bearing the news. As he told Ruskin, who reported it to Thornbury, he 'feared to break the dead silence, varied only by the slippered scrape of Turner's feet as he paced from end to end of the dim and dusty apartment. At last he stood abruptly, and turning to me, said, "Mr. Hammersley, you *must* excuse me; I cannot stay another moment; the letter I hold in my hand has just been given to me, and it announces the death of my friend Callcott". He said no more; I saw his fine grey eyes fill as he vanished'.[79]

[46]

Notes and references

1 Turner to Callcott, undated, in Gage, *Correspondence*, p.231.
2 Collection of the late Mr Maurice Whitelegge.
3 Collection as above.
4 Farington, 5 January 1798.
5 *Ibid.*, 20 June 1805.
6 *Ibid.*, 20 March 1805.
7 Collection of the late Mr Maurice Whitelegge.
8 *Loc.cit.*
9 M. Hardie, *Water Colour Painting in Britain*, III, 1971 ed., p.273.
10 Farington, 8 June 1811.
11 *Ibid.*, 8 April 1813.
12 *Ibid.*, 26 December 1812. For an account of Turner's attitude towards the Institution see Katharine Nicholson, 'Turner's "Appulia in Search of Appulus" and the dialectics of landscape tradition', *Burlington Magazine*, CXXII, 1980, pp.679–686.
13 *Ibid.*, 29 March 1813.
14 *Ibid.*, 8 April 1813.
15 *Ibid.*, 15 April 1813.
16 *Ibid.*, 3 May 1813.
17 *Ibid.*, 16 April 1813.
18 *Ibid.*, 1 December 1814.
19 Victoria and Albert Museum Library.
20 Finberg, p.226.
21 Farington, 4 November 1816.
22 *Ibid.*, 9 June 1815.
23 *Ibid.*, 11 February 1809.
24 J. Lindsay, *J.M.W. Turner. A Critical Biography*, 1966, p.113.
25 Farington, 8 June 1811.
26 See Finberg, pp.177ff.
27 *Ibid.*, p.231.
28 *Ibid.*, p.218.
29 Turner to Holworthy, 4 December 1826, in Gage, *Correspondence*, p.103.
30 Turner to Eastlake, August 1828, in Gage, *Correspondence*, p.118.
31 Eastlake to Maria Callcott, in Gage, 1968, pp.679–80.
32 Farington, 12 October 1812.
33 *Ibid.*, 6 May 1806.
34 *Ibid.*, 5 April and 11 July 1806.
35 Constable to Dunthorne, 23 May 1803, in Leslie, p.17.
36 Farington, 15 April 1813.
37 Gage, 1965, parts I and II, pp.16–26 and 75–81.
38 Collection of the late Mr Maurice Whitelegge.
39 On these see Gage, 1965, part II, p.76.
40 Gage, 'Turner and Stourhead: the Making of a Classicist?', *Art Quarterly*, XXXVII, 1974, p.85, note 15.
41 Thornbury, p.430.
42 Redgrave, pp.344–5.
43 Letter to *Annals of the Fine Arts*, 1816; an MS. version belongs to the Wiltshire Archaeological Society.
44 Recorded in Callcott's MS. catalogue of his own pictures.
45 *Examiner*, 1811, p.380.
46 E. Mason, *The Mind of Henry Fuseli*, 1951, p.175.
47 Farington, 5 May 1807.
48 For full accounts of Callcott's replica see Brown, 1975, and Butlin and Joll, pp.41–2, No.62 and p.281, Nos 542–3.
49 Thornbury, p.275.
50 Victoria and Albert Museum Library, press cuttings, IV, p.1156.
51 *Diary, Reminiscences and Correspondence of Henry Crabb Robinson*, I, 1872, p.329.
52 Review sent by Turner to Robert Balmanno, ? April, 1826, in Gage, *Correspondence*, pp.98–100.
53 *Ibid.*
54 Wilton, p.385, No.735.
55 Copy in a sketchbook of drawings by Crotch after Callcott, mainly made at the 1845 Callcott executors' sale, Norwich Central Library, Nor MSS., 1108.
56 Wilton, p.386, No.749.
57 *Ibid.*, p.386, No.746.
58 *Ibid.*, p.387, No.756.
59 *Ibid.*, p.357, No.505.
60 *Ibid.*, p.387, No.753.
61 *Art Union*, IV, 1842, p.122.
62 Maria Callcott's Journal for 1829, collection of the late Lady Robinson.
63 M. Bennett and E. Morris, *The Emma Holt Bequest, Sudley*, 1971, p.16, No.195 as 'Italian Landscape'.
64 Maria Callcott's Journal for 1829, *loc.cit.* above.
65 *Ibid.*

66 *Ibid.*

67 See Butlin and Joll, p.128, No.233.

68 The poem is preserved in a transcription by William Hutchins Callcott, attached to Callcott's *Fragments of Family History*, collection of the late Lady Robinson.

69 Note by Kingsley appended to Ruskin's catalogue of his collection of Turner drawings; see Cook and Wedderburn, XIII, p.534, note 50. On the subsequent use of reduced copies of some of the Scottish views by Turner and Callcott in Charles Tilt's *Illustrations: Landscape, Historical, and Antiquarian, to the Poetical Works of Sir Walter Scott Bart*, 1834, and Turner's attempt, heard before the Lord Mayor at the Mansion House in October, 1833, to prevent Tilt from using his work, see 'The Turner – Tilt Affair', appendix to G. Finley, *Landscapes of Memory. Turner as Illustrator to Scott*, 1980, p.229ff.

70 Whitley Papers, British Museum Print Room.

71 Callcott to Barry, 15 October 1833, Royal Academy Library, Callcott papers, CA/1.

72 *The Spectator*, 10 May 1834.

73 *The Morning Post*, in W.T. Whitley, *Art in England 1821–1837*, 1930, p.235.

74 *The Times*, 11 May 1836.

75 Cook and Wedderburn, VII, p.454.

76 Anna Jameson, *Visits and Sketches at Home and Abroad*, 1834, I, p.139.

77 Rippingille in *The Art Journal*, 1860, p.100.

78 Cook and Wedderburn, III, p.648.

79 Thornbury, pp.279–80.

Catalogue

The dimensions are given in centimetres
followed by inches in brackets; height precedes width.

JOHN LINNELL (1792–1882)

1 **Portrait of Callcott** R.A. 1832

Oil on panel; 35×28 ($13\frac{3}{4} \times 11$)
Yale Center for British Art, Paul Mellon Collection.

Though thirteen years younger than Callcott, Linnell was one of his earliest professional friends and always remained close to him. The two first met through William Mulready, to whom Callcott must have been introduced by the Varley family. Callcott would have encountered Mulready at an early stage through his fellow member of Girtin's Sketching Club, William Fleetwood Varley; Mulready was staying with the Varleys at least by 1802, and Callcott could have met him at their house. Callcott, Mulready and the Varleys are frequently mentioned together at unspecified dates, notably in the well-known story of Callcott's horoscope – that he would remain single until he was fifty and would then marry and go to Italy – cast by John Varley and handed to Mulready for safe keeping.[1] Linnell, already a protegé of Mulready and the Varleys, probably joined this group around 1806. In 1809 Mulready moved his family to Kensington Gravel Pits, having presumably found a house while visiting Callcott there, and soon afterwards brought Linnell to stay with him. At Kensington Mulready and Linnell continued to follow the programme of outdoor study and precise transcription from nature advocated by John Varley, respectively producing the pair of canvases of 'The Mall' and 'Near the Mall' (Victoria and Albert Museum), and 'Kensington Gravel Pits' (Tate Gallery). Callcott seems to have had mixed feelings about these efforts.

Although he himself obtained for Mulready the commission for the first two paintings, he found them on completion 'too literal' and declined to recommend them to their purchaser.[2] His opinion of Linnell's picture is not recorded.

Linnell painted this portrait in 1831 or early in 1832, in which year it was exhibited at the Royal Academy (362). As far as is known Callcott never painted Linnell, but he did paint a spirited half length of Mulready, now lost.[3] Callcott was renowned for his good looks and various portraits exist. In addition to the fine pencil drawing made during his visit to Dresden by Carl Vogel (Staatliche Kunstsammlungen, Dresden; frontispiece), there are drawings by Penry Williams (British Museum) and Francis Chantrey (National Portrait Gallery). In the early 1830s Callcott sat to Landseer for the head of the monk in his 'Bolton Abbey in the olden Time' (Chatsworth); a study of the head, almost certainly drawn after Callcott, appears in a chalk drawing in the Royal Collection, and an oil study, doubtless that recorded by J.C. Horsley as having been painted 'al prima and exquisitely finished in a sitting of three of four hours'[4], is in the National Portrait Gallery.

[1] Redgrave, p.342.
[2] Stephens, p.61.
[3] Repr. Horsley, opposite p.18.
[4] Ibid., p.238.

[50]

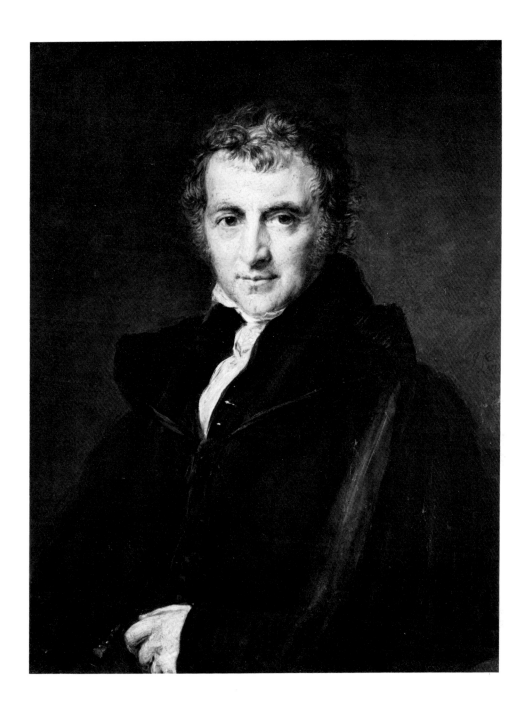

CHARLES TURNER (1774–1857) after Callcott

2 The Water Mill

Mezzotint; 60 × 43 (23⅝ × 17)
Victoria and Albert Museum.

Charles Turner's mezzotint was engraved in 1812, after Callcott's large painting (235 × 154cm.) shown at the Royal Academy in 1805 (22); the original is in a private collection. The picture was acquired before the opening of the exhibition by Sir John Leicester, apparently partly on the advice of Henry Thomson; on 20 March 1805, Thomson visited Farington and told him that 'He was at Kensington a day or two since to see an Landscape, an *Upright* painted

fig.13

by Calcott, and was much struck with it. Sir John then bought it for 80 guineas'.[1] Sir John was the most munificent of all Callcott's patrons, owning at various times seven of his paintings, but he kept only three long enough for them to be included in the catalogues of his collection by William Carey (1819) and John Young (1821). According to James Ward, he was thinking of selling 'The Water Mill', together with several of his paintings by Turner, by February, 1809,[2] and in about 1810 he did dispose of it to another of Callcott's patrons, William Chamberlayne, probably as part of a package deal also including the two coast subjects Callcott showed at the Academy in 1806 (see Nos 3 and 4). None of these three paintings are mentioned by Carey or Young.

'The Water Mill' was the first of Callcott's exhibited works to win wide acclaim. Thomas Hearne heard it compared to Ruysdael – a view he thought exaggerated[3] – and Farington, after touring the exhibition with the Academy council, noted that 'Gilpin's Horses, – Calcott's upright landscape of a Mill &c, – Lawrence's Portrait of Mr. Hoare, – a Half length by Hoppner, – were the artists most admired'.[4] The composition is one of Callcott's most elaborate and personal exercises in the picturesque, and a crucial example of the mode in English landscape painting in the early nineteenth century. It depends hardly at all on nature, and is in fact a highly eclectic picture. Callcott may have recalled the early Turner drawing of a 'Water

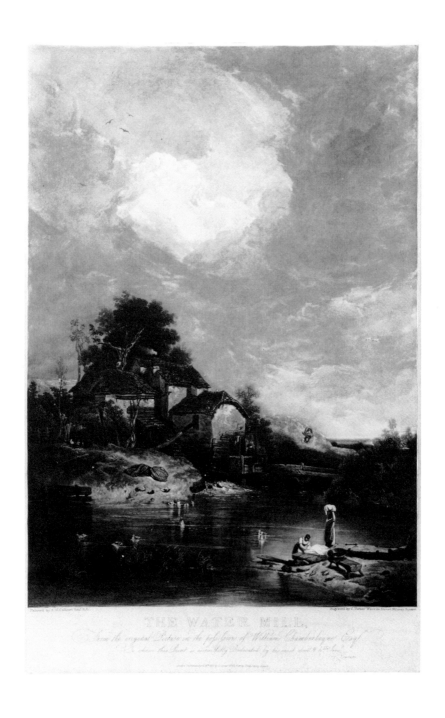

THE WATER MILL,

From the original Picture in the possession of William Chamberlayne Esqʳ.

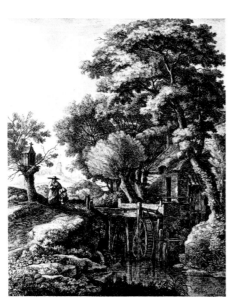

fig. 14

Mill' which, as we have seen, made such an impression on him as a young man; and certain of Turner's early watercolours of such subjects, for instance the 'Marford Mill' (National Museum of Wales; fig. 13), exhibited at the Academy in 1795, do have many features in common with Callcott's picture. Equally important must have been Dutch seventeenth century prototypes. The composition might be traced to a source such as Waterloo's etching of a similar subject (fig. 14); the trees, and especially the device of setting a dead trunk against a living growth, do indeed recall Ruysdael; and the low siting of the mill building, so that it falls into rhythm with the contours of the ground, seems to echo the dune landscapes of Jan van Goyen or Pieter Molijn. At the same time there is a decorative, almost rococo quality about the scene reminding one of the mill subjects of Boucher, which Callcott could have known through engravings. Despite the brightness of the sky, Callcott has not denied himself those chiaroscuro contrasts which play so significant a part in the picturesque landscapes of Turner and Crome; but they are not pronounced, and Callcott has in fact muted the picturesque features so as to achieve a more restrained and ideal pastoral mode. As already suggested, 'The Water Mill' may have been a factor in prompting Turner towards a redefinition of picturesque values, and to distinguish plain pastoral from a more exalted category in the *Liber Studiorum*. The plate of 'Pembury Mill' (fig. 15) presents many of the picturesque elements of 'The Water Mill' in concentrated form and in a functional situation, corresponding to the 'common pastoral' of which Turner wrote in his annotations to Shee's *Elements of Art*; the monumental and elegiac treatment in Callcott's picture finds its truest analogies in the 'elevated' or 'epic' pastoral of the *Liber*.

[1] Farington, 20 March 1805.
[2] *Ibid.*, 21 February 1809.
[3] *Ibid.*, 4 July 1805.
[4] *Ibid.*, 4 April 1805.

fig.15

Augustus Wall Callcott (1779–1844)

3 A Sea-Coast, with Figures bargaining for Fish R.A. 1806

Oil on canvas; 122 × 183 (48 × 72)
Private collection (exhibited in a photograph).

This painting and the following were acquired by Callcott's patron, William Chamberlayne of Weston Grove, not directly from the artist but almost certainly from Sir John Leicester, together with 'The Water Mill'. The subjects agree perfectly with the titles of the two coast scenes Callcott exhibited at the Royal Academy in 1806 (241 and 290). The 'Sea-Coast with Figures bargaining for Fish', with which this painting may be identified, was commissioned for 60 guineas by Sir John, who thus acquired it a year after he purchased the splendidly squally 'Coast Scene with Fishermen setting out' painted by Gainsborough *c*.1781–2 (National Gallery of Art, Washington, Ailsa Mellon Bruce Collection), and in the same year as he bought his first Turner, 'The Shipwreck' (Tate Gallery); Callcott's other 1806 exhibit, 'A Calm, with Figures: Shrimping', was painted for Sir John's relative, Thomas Lister Parker of Browsholme Hall (for whom see No.7). In 1808 Parker transferred his 'Calm' to Sir John, thus reuniting the two pictures which had first established Callcott's close relationship with the art of Turner, and had become focal points for Sir George Beaumont's attacks on the artists as 'white painters'.

On first seeing the 1806 coast scenes in Callcott's Kensington studio in April, Beaumont reported them to Farington 'as being like pictures by Ruysdael, which had been worn down and then worked upon in a fuzzy manner, but ... there were silver grey skies well imitated, and good colour'.[1] Hardly a week later, however, he was complaining of the 'white look of Callcott's pictures',[2] and he continued to voice this criticism for some years. It was probably the 'Calm' which did most to attract it, but the cold colours and pronounced scumbling with white in the sea in the present picture would also have justified it, and accounted for James Northcote's remark that Callcott's paintings 'now seemed as if executed with *mortar*'.[3] These characteristics were generally ascribed to Turner's influence, and it is strange that Beaumont did not notice this at once; Northcote observed that Callcott had 'founded Himself on Turner's manner ... and had leapt out of the frying pan into the fire',[4] and a better disposed critic, Thomas Hearne, probably had the 1806 pictures in mind when in 1809 he remarked that Callcott 'had done some coast scenes, imitating Turner, pretty well'.[5]

This painting certainly depends upon Turner both technically and compositionally. The diagonal thrusts of shore line and pier are derived from such works as Turner's 'Fishermen upon a Lee-Shore' shown at the Academy in 1802 (Southampton Art Gallery), while the vigorous treatment of the sea – deep blue/green waves flecked with white foam – might have been inspired by the 1803 'Calais Pier' (National Gallery). The figure types are also modelled on Turner's maritime characters, although they are painted with rather more detail, a point which commended the 'Sea-Coast' to Farington's Norfolk acquaintance Mr Dashwood, who while denouncing Turner's 'Fall of the Rhine at Schaffhausen' (Museum of Fine Arts, Boston) as a 'wild incoherent production', 'spoke with great admiration of Callcott's picture the Sea Shore Scene, and said it was equal to Backhuysen or De Vlaiger – The figures, He said, were made out, not left *blots* like Turner's'.[6]

[1] Farington, 5 April 1806
[2] *Ibid.*, 13 April 1806.
[3] *Ibid.*, 6 May 1806.
[4] *Ibid.*
[5] *Ibid.*, 4 July 1809.
[6] *Ibid.*, 11 May 1806.

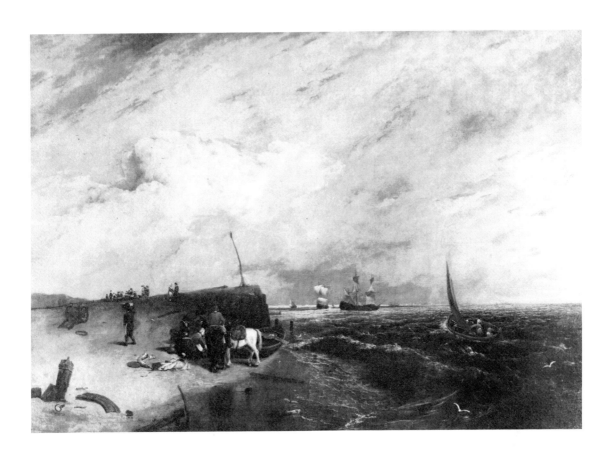

4 A Calm, with Figures: Shrimping R.A. 1806

Oil on canvas; 122 × 183 (48 × 72)
Private collection (exhibited in a photograph).

This painting is identifiable with the 'Calm' exhibited at the Royal Academy in 1806 (290), having been commissioned by Thomas Lister Parker of Browsholme Hall. Callcott wrote of the commission to Sir John Leicester, 7 November 1805,[1] but did not name his price; in 1808 Sir John himself bought the painting from Parker for 60 guineas,[2] the same sum he had given Callcott for the 'Sea-Coast' two years earlier. Both paintings were acquired by William Chamberlayne, c.1810.

Of the two works the 'Calm' was the more inventive, and hence the more controversial. All the forms are veiled in a pallid silvery haze, and although the shrimper in the immediate foreground stands out fairly clearly, the two fishing boats in front of the pier in the middle distance, and the larger ships on the horizon, appear only dimly; thus Benjamin West declared it 'only the *Ghost* of a picture'.[3] Like the 'Sea-Coast' exhibited with it, this was recognised immediately as a Turnerian work, and with hindsight it might seem even more so; but it actually goes rather further towards atmospheric abstraction than most of Turner's work to date. In Callcott's case, however, this tendency probably owed more to study of Dutch painters such as Jan van de Cappelle than to observation of natural effects.

[1] Hall, p.66.
[2] A note of this sale, dated September 1808, is at Tabley; see Hall, *loc.cit.*
[3] Farington, 2 July 1806.

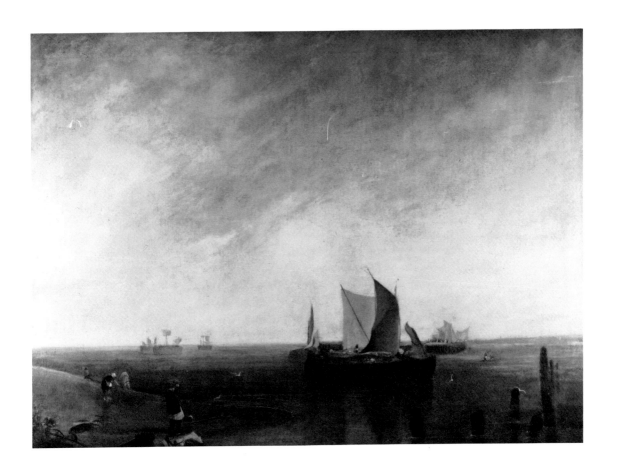

5 Market Day R.A. 1807

Oil on canvas; 147.3 × 256 (58 × 100¾)
University of Manchester, Tabley Collection.

Exhibited at the Royal Academy in 1807 (18) and purchased by Sir John Leicester, probably for 150 guineas.[1] Hung near each other as they would almost certainly have been originally, this painting and the 'Cow Boys' (No.6) exemplify the two chief trends in Callcott's landscape art in its first maturity. The dense picturesque details and heavy chiaroscuro of 'Market Day' form a powerful, and no doubt intentional, contrast with the monumental but simple composition, generalised landscape setting and pervasive light of 'Cow Boys'. Both pictures are modelled on Dutch prototypes, in the present case mainly on Ruysdael and Hobbema; the composition, with its winding road and different views each provided with their own detail and interest, is particularly based on the latter master. The painting is remarkable for the high finish and rather mannered brushwork which prevails throughout the canvas, and for its stormy and overcast sky.

'Market Day' attracted hardly less attention than 'The Water Mill' (No.2), not all of it favourable. The labour and artifice which had gone into it were generally admired, but it was recognised that this was purely a studio composition; critics also felt that Callcott had strayed into hard and unrealistic contrasts of colour, and had given too much weight to the dark, positive tones. Benjamin West told Farington that 'Calcott seemed to be in danger of falling into *Manner*, & wanted *middle tint* in his pictures which deficiency caused his large picture to appear by any other than *broad day light* a mass of *dark* upon a mass of *light*, wanting the sweetness and agreeableness of medium tints';[2] the trees West considered 'like *fried parsley*'.[3] Even Henry Thomson, who greatly admired the painting, was aware of a certain unhappiness of colour; he told Farington it was 'an extraordinary production, many parts as

well painted as anything he had ever seen, – a little tendency to blackness only to be avoided'.[4] For Constable the high finish, particularly in the trees which are built up of countless small, cursive brush strokes, added to the sense of artificiality which others noticed in the colouring; he thought it 'a fine picture, but treated in a *pendantick* manner, every part seeming to wish to shew itself; that it had not the air of *nature*; that the trees appeared crumbly – as if they might be rubbed in the hand like bread, not loose and waving, but as if the parts if bent would break, the whole not lived like Wilson's pictures, in which the objects appear floating in sunshine'.[5] A little later Constable summed up his opinion, 'too much a work of art & labour, not an *effusion*';[6] and not the least interest of the picture today must be that it called forth such an elaborate critique, from which so much of Constable's personal credo may be deduced. James Northcote echoed his complaints, declaring that 'Callcott's Pictures are landscapes made up in a room'.[7]

'Market Day' was the only one of Callcott's pictures to remain at Tabley. It was included in the catalogues of the Leicester collection by Carey and Young, being illustrated in the latter in an outline etching by Young himself (p.27), and was shown again at the Royal Academy in 1879 (167).

[1] Callcott's receipt for this sum, probably of 1807 and referring to 'Market Day', is at Tabley; see Hall, p.67.
[2] Farington, 7 April 1807.
[3] *Ibid.*, 5 May 1807.
[4] *Ibid.*, 23 January 1807.
[5] *Ibid.*, 13 March 1807.
[6] *Ibid.*, 1 April 1807.
[7] *Ibid.*, 25 April 1807.

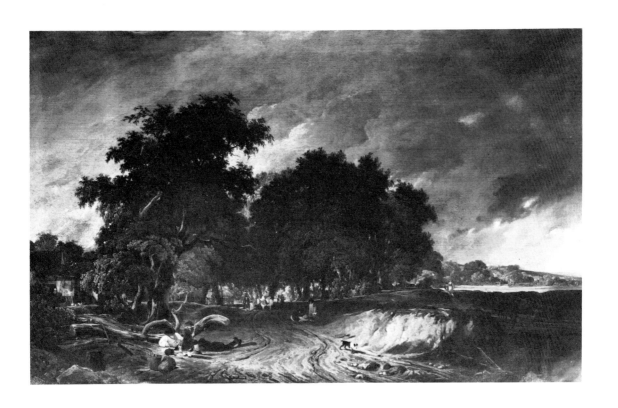

6 Cow Boys R.A. 1807

Oil on canvas; 125 × 102 (49¼ × 40⅛)
Herbert Art Gallery, Coventry.

A work of this title was exhibited at the Royal Academy in 1807 (308) and at the British Institution the following year (260); it was bought from Somerset House by Sir John Leicester for 70 guineas, together with the 'Market Day' shown the same year.[1] Dafforne first stated that he had 'no clue whatever to it'[2] and then confused it with a later picture, 'Shepherd's Boys with their Dogs', painted for the 3rd Marquess of Lansdowne.[3] It may, however, be most convincingly identified with the painting here exhibited. The subject would fit Callcott's title; Farington's notes that Sir John Leicester had bought a 'Landscape, *Evening*, of which Thomson speaks highly', but from which 'half the sky might be taken away and the picture would be better for it',[4] would imply a composition with a large expanse of sunset sky such as appears here; and moreover Farington twice describes the 1807 canvas as an 'upright'.[5]

Thomson thought 'Cow Boys' 'of a better colour' than Turner's 'Sun rising through Vapour',[6] and this painting is indeed the most advanced example thus far of Callcott's diffused lighting and carefully modulated tones, those qualities which combined to produce what Sir Richard Colt Hoare called his 'own original style of colouring'. In this respect, as already remarked, the painting is the exact antithesis of the sombre and heavily contrasted 'Market Day'. The lambent sunset effect, and an economy of detail in the landscape, enables Callcott to achieve a new refinement of the pastoral mode, and a timeless, almost classic mood. The lighting, *contre-jour* placing of the figures and low viewpoint are derived from Cuyp; aspects of the composition, notably the upward sweep of the hill on the right, and the position – though not the pose – of the figures, might suggest that Callcott had in mind the celebrated 'Herdsman with Cows' (Dulwich College; fig.16), which he could have seen in the Bryan sale in 1798 and perhaps subsequently in the collection of Sir Francis Bourgeois. The painting also springs from the popular eighteenth-century tradition of idealised pastoral scenes of childhood, and shows Callcott moving tentatively into the same area in which his friend Mulready was soon to prove so successful. Indeed 'Cow Boys' was painted at the very period when Mulready was turning from pure landscape to genre, and Callcott's rustic figures interestingly parallel the protagonists of Mulready's earliest and more restrained subject pictures. However, Callcott's figures were rarely to achieve the liveliness or humour which Mulready's developed in the following years.

'Cow Boys' was not included in the Leicester catalogues by Carey and Young and therefore must have been sold by Sir John before 1819; Callcott's MS. list of his work states it to have been 'bought afterwards by Mr. Agar'. The Coventry picture is first firmly documented in the collection of Holbrook Gaskell, and later in that of Lord Kenilworth, by whose Crackley Trust it was presented to the Museum in 1954. It was exhibited at the Royal Academy in 1875 (265, as 'Landscape with Figures, Sunset') and at Coventry in 1975, *The Cloud Watchers, Art and Meteorology 1770–1830*, (25, under the same title).

[1] Callcott's receipt for that sum, dated 28 February 1808, is at Tabley; see Hall, p.66.
[2] Dafforne, p.23.
[3] *Ibid.*, p.25.
[4] Farington, 31 March and 7 April 1807.
[5] *Ibid.*, 7 April 1807.
[6] *Ibid.*

fig.16

[63]

7 The Junction of the Thames and the Medway (after Turner) c.1808

Oil on canvas; 70 × 89.5 ($27\frac{1}{2}$ × $35\frac{1}{4}$)
Tate Gallery.

A reduced copy of Turner's marine in the National Gallery of Art, Washington D.C.; a full-size replica by Callcott is at Browsholme Hall, Yorkshire, the home of the Parker family. From the replica it was possible to identify the Washington picture, whose early history had been uncertain, with the 'fine seapiece by Turner . . . in his best manner' which *The Morning Post* (6 May 1807) reported had been bought by Thomas Lister Parker; it had evidently been exhibited in Turner's gallery, where Thames estuary subjects were shown in 1807 and the two following years.[1] The painting is listed in an 1807 catalogue of Parker's collection, which at this time consisted almost entirely of old masters, the other exception being Callcott's 'Calm' acquired the previous year (No.4);[2] the Turner was indeed only the second major work by a contemporary British painter to be bought by Parker, who had known Turner since at least 1799, when Turner made a drawing of the north front of Browsholme (private collection). Parker, who was exactly Callcott's contemporary, had been Sir John Leicester's guardian, and as his obituary in *The Gentleman's Magazine* records, 'assisted him in selecting his valuable gallery of paintings';[3] he was also a friend of Walter Fawkes, and may well have encouraged both northern gentlemen to befriend and employ Turner. Leicester, however, was considerably in advance of Parker as a patron of living artists, for it was only in 1808 that the latter began to concentrate seriously on their work, having sold most of his old masters that year.[4]

Parker also tried to dispose of his Turner in 1808, but it must have been bought in as it reappeared with a Parker provenance at Christie's in 1811.[5] Parker seems to have bought partly for investment, and his reason for such an early attempt to sell the Turner may be implicit in his entry for it in his catalogue of his collection, which states that 'The works of this great English artist are now even so highly prized as to bear the same prices with the most celebrated of the Dutch or Flemish schools'. However, the picture must have failed to reach its reserve in 1808, and this may have discouraged Parker from what I believe to have been a proposed purchase of a second Turner, the 'Whalley Bridge and Abbey' of 1811 (Loyd Collection). Whalley is close to Browsholme, and Parker had assisted its vicar, his friend the Revd Thomas Whitaker, in his *History of Whalley*, 1800–1, so the subject would have been an appropriate one; moreover, there is the circumstantial evidence that both the 'Whalley' and the 'Thames and Medway' belonged to John Newington Hughes of Winchester, and were acquired the same year.[6]

Turner and Callcott were the first contemporary artists to catch Parker's eye. He had commissioned Callcott's 'Calm' (No.4) in 1805, and in 1808 he bought a 'River Scene' (whereabouts unknown) from the Academy, having sold the 'Calm' to Sir John Leicester; the 'River Scene' also went to Tabley in 1809. In 1806 Callcott stayed at Tabley and Browsholme, and almost certainly returned to both houses in 1808. If so, he would probably have encountered Turner, who was then making further studies in the Ribble valley, including that which was to be the genesis of Whalley Bridge;[7] this was too far from Tabley, where Turner also stayed that summer, to be covered conveniently in day excursions, and it is likely that Turner took time away from Tabley to stay with Whitaker or with Parker himself. Under such circumstances Parker would hardly have given Callcott a direct commission to paint a replica of the Turner so he could sell the original, and it is more probable that Callcott, while visiting Browsholme, made

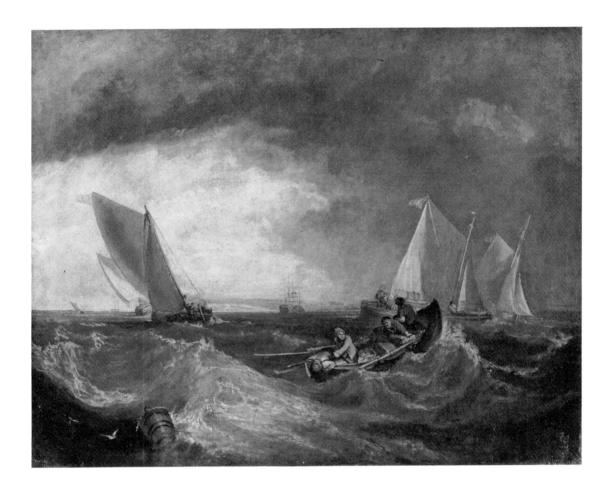

a small copy for his own instruction which suggested the idea to Parker later on.

A small and freely handled copy in the Ashmolean Museum might be regarded as Callcott's initial sketch,[8] while the present picture, which is larger and more finished, and approximates more closely in technique to the original, could have been submitted to Parker as some indication of the likely success of a full-scale replica. The finished work at Browsholme, the only known instance of a replica by Callcott after Turner, is highly convincing; in Parker's *Description of Browsholme Hall in the West Riding of the County of York*, 1815, it is listed as if it were an original composition, as 'A Gale of Wind, by William Calcott(*sic*) Esq., R.A.'

[1] The correct identity of the Washington picture, and the replica at Browsholme, were first published by Brown, 1975.
[2] Information about the 1807 catalogue was kindly furnished by the late Colonel Robert Parker.
[3] *Gentleman's Magazine*, Vol. 49 (1858), p.447.
[4] Details of this sale were also provided by Colonel Parker.
[5] Christie's, 9 March 1811, lot 29.
[6] For a summary of my views on 'Whalley Bridge', see Butlin & Joll, pp.74–5, no.117.
[7] See the first 'Tabley' sketchbook, Turner Bequest (CIII).
[8] Brown, 1975, fig.38; Butlin & Joll, p.281, pl.521.

8 Richmond Bridge *c*.1807–10

Oil on paper laid on panel; 19 × 26.7 ($7\frac{1}{2}$ × $10\frac{1}{2}$)
Signed at left lower corner *A.W. Callcott.*
Yale Center for British Art, Paul Mellon Collection.

This attractive and spontaneous little painting is likely to date from between *c*.1807 and 1810, a period when Callcott probably made a number of such sketches. A stimulus for these may have been Turner's Thames views shown in his gallery in 1807 and the two following years. In addition to Turner, Callcott's friends Mulready and Linnell were practitioners of the oil sketch, the latter working along the Thames on the advice of John Varley; perhaps Callcott sometimes accompanied him on such expeditions, and the freshness of 'Richmond' would suggest that it was painted on the spot. Although he told Samuel Palmer that 'a picture done out of doors must needs be false, because nature is changing every minute',[1] and the Redgraves, who only knew him in his later years, asserted that he 'never painted directly from nature',[2] Callcott was far from being untouched by the trend towards *plein air* oil sketching in the early years of the nineteenth century; of the oils in the 1845 Callcott executors' sale, *The Art Union* reported that 'the majority were "sketches" – early sketches exhibiting amazing power, and which afforded a contrast disadvantageous to the later style of the accomplished painter',[3] and in 1812 Callcott in fact exhibited three 'studies from nature', including No.13 below, at the British Institution.

[1] Palmer to P.G. Hamerton, October 1871, in *The Letters of Samuel Palmer*, ed. R. Lister, II, 1974, pp.821–2.
[2] Redgrave, p.345.
[3] *The Art Union*, 1 June 1845.

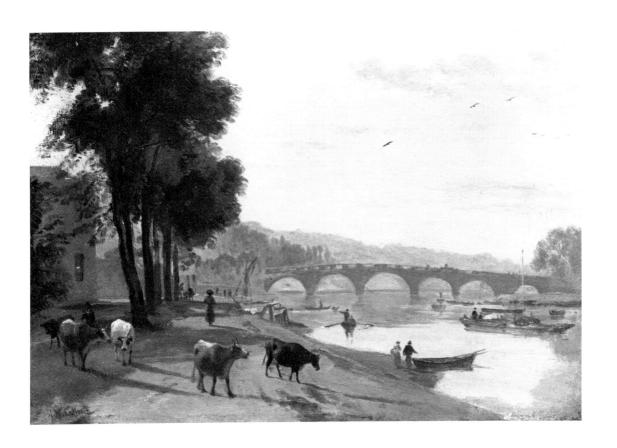

9 A Mill near Corwen *c.*1808

Oil on canvas; 65.4×79.4 ($25\frac{3}{4} \times 31\frac{1}{4}$)
The National Trust (Hoare Collection, Stourhead).

This was painted for Sir Richard Colt Hoare as a companion to another Welsh subject, 'A Mill near Llangollen, from a sketch by Sir Richard Colt Hoare Bart.', of which the first version was shown at the Royal Academy in 1808 (83), and a second, made as a replacement after the original was destroyed, in 1812 (198). The present picture presumably belongs to the earlier date, and may also have been based on a sketch by the patron, although no such drawing has come to light among the albums of Colt Hoare's drawings still at Stourhead. Sir Richard was Callcott's most loyal ally among the directors of the British Institution; he bought his 'Diana and Actaeon' (fig.4) when Callcott's reputation was at a low ebb due to criticism from his colleague Sir George Beaumont, and in contrast to Beaumont's attacks on Callcott as a 'white painter', he praised the artist in 1816 for his 'own original style of colouring'.[1] 'Corwen', a work built up almost entirely in golds and greys with the notes of positive colour concentrated in the figures, is an excellent example of that manner as applied to a picturesque subject. It must have been paintings such as this that Thornbury had in mind when he remarked of Turner's 1810 'Abingdon' or 'Dorchester Mead' (Tate Gallery; fig.3) that 'the style is after Calcott';[2] and if 'Corwen' was painted *c.*1808, its colouring also finds analogies with Turners of the same date such as 'Pope's Villa' (Walter Morrison Picture Settlement) or 'The Union of the Thames and the Isis' (Tate Gallery; fig.2), both of which were shown in Turner's gallery that year.

[1] Letter to *Annals of the Fine Arts*, 1816; an MS. belongs to the Wiltshire Archaeological Society.
[2] Thornbury, p.430.

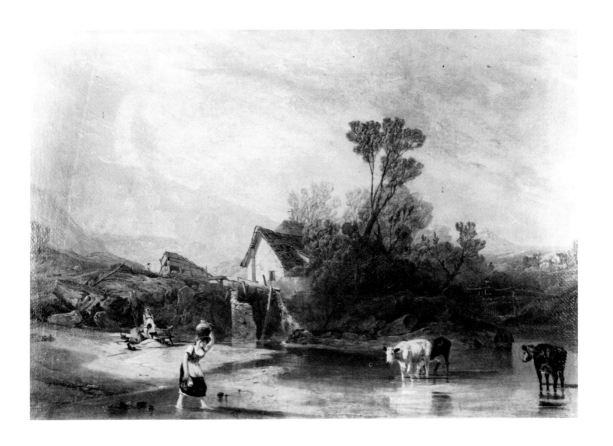

10 Morning R.A. 1811

Oil on canvas; 100 × 133.3 (39⅜ × 52½)
Signed and dated at right lower centre *A.W. Callcott R.A. 1810.*
Royal Academy of Arts.

Exhibited at the Royal Academy in 1811, this was Callcott's diploma picture. For such an important work he chose to emphasise the picturesque features which had characterised his landscape painting so far, and to avoid the controversial pale colouring with which he was widely associated. The figures are more numerous and prominent than in Callcott's earlier landscapes, and in its rustic genre 'Morning' recalls not only Ostade and Teniers, and Morland and Wheatley, but also Callcott's friends Wilkie and Mulready; piquant details such as the two boys being seen off to school by their mother, one with equanimity, his younger brother unwillingly, even tearfully, are particularly close to Mulready's work. The picture also has affinities with the vein of rustic narrative being explored by Turner, both in the 'pastoral' subjects of the 'Liber' and in compositions such as the watercolour, 'May: Chickens' (private collection, Japan),[1] also shown at the Academy in 1811. 'Morning' was exhibited at the British Institution in 1845 (129), at the Manchester Art Treasures Exhibition in 1857 (233), twice more at the Academy in 1872 (21) and 1896 (90), and at Nottingham University Art Gallery, *Diploma Works and other Paintings by Early Members of the Royal Academy*, 1959 (2).

[1] Wilton, p.356, no.490, repr. p.115, pl.117.

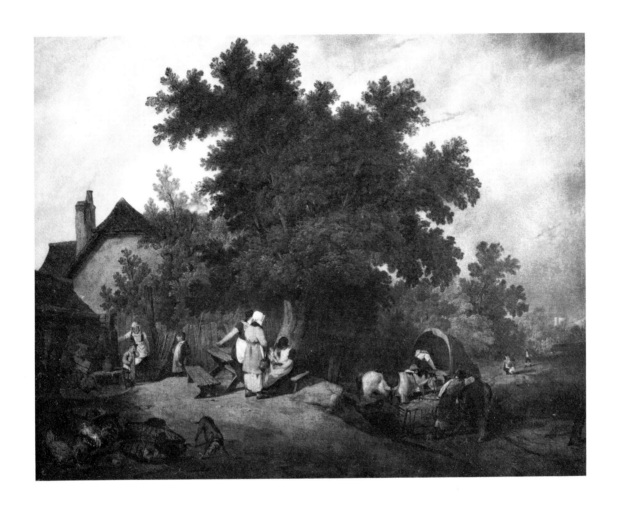

11 Southampton from Weston Grove, the Seat of William Chamberlayne, Esq R.A. 1811

Oil on canvas; 120 × 183 (47¼ × 72)
Private collection (exhibited in a photograph).

William Chamberlayne, solicitor to the Treasury and M.P. for Southampton, was a collector and patron of British artists including Thomson – who drew his portrait – Richard Westall and Henry Richter. His purchase of 'The Water Mill' (No.2) and the two 1806 coast scenes (Nos 3 and 4) from Sir John Leicester has already been mentioned; the sale was probably arranged in 1810, when Callcott spent two months in the autumn with him at his estate, Weston Grove, overlooking Southampton Water. The visit was a great success. Callcott returned to 'speak highly of the benevolent and agreeable disposition of Mr Chamberlain', telling Farington 'He never passed two months more happily'.[1]

Farington also records that during Callcott's stay at Weston he 'painted there', and in December Richard Westall told him that Callcott 'had painted two large pictures for Mr Chamberlain, one of them a view from a window of the House, a very complete subject'.[2] This was the present picture, the other being the following view of 'Itchen Ferry', and Callcott's commission from his host also included a copy of a German print of Lausanne, now lost. At the same time he probably began a painting of 'Southampton Castle' (Ashmolean Museum) for Lord Lansdowne, who used the castle as a summer residence and entertained artists there; no doubt Callcott visited it while staying with Chamberlayne. 'Southampton Castle' is a very Claudian picture, a pastiche in upright format of the 'Enchanted Castle', which he presumably saw in the Buchanan sale in April that year, and of which he later made a more direct copy when it belonged to William Wells at Redleaf. By contrast 'Southampton from Weston Grove', which was shown with 'Itchen Ferry' at the Royal Academy in 1811 (141), is more naturalistic, the product of concentrated exposure to the scene represented. A hazy, sultry effect of light,

harvesters resting, bonfire smoke and similar elements evoke a powerful autumnal atmosphere, and in this seasonal quality the painting shows a distinct advance on a studio composition such as the 1807 'Market Day' (No.5). At the same time the picture is organised in an almost Poussinesque system of diagonals, leading the eye into the distance along Southampton Water to the town itself, spread across the horizon beneath a cloudy sky. This arrangement suggests that Callcott had strongly in mind Turner's 'London from Greenwich' (Tate Gallery) which had been shown at the Academy in 1809, and whether or not Mr Chamberlayne had stipulated just this view, Callcott must also have remembered Turner's exhibits of 1810, which had included a high proportion of works in which the conventions of country house portraiture had been reconciled to pure landscape – 'Linlithgow Palace, Scotland' (Walker Art Gallery), 'Cockermouth Castle' and 'Petworth, Dewy Morning' (Petworth), and the evening and mid-day views of Lowther Castle (private collection). The beautiful 'Somer Hill' (National Gallery of Scotland), shown the same year as 'Southampton from Weston Grove', carries this assimilation still further; Callcott's picture might be seen as a more self-conscious but by no means undistinguished effort in the same direction.

Callcott was on the hanging committee in 1811 with Turner, Fuseli and Rossi, and not only exceeded the permissible number of exhibits but hung his own in the 'very best positions'.[3] This did not pass without comment, and may partly explain why 'Southampton' and 'Itchen Ferry', both commissioned pictures, were the only works he sold that year.

[1] Farington, 15 December 1810.
[2] *Ibid.*, 16 December 1810.
[3] W.T. Whitley, *Art in England 1800–1820*, 1928, p.187.

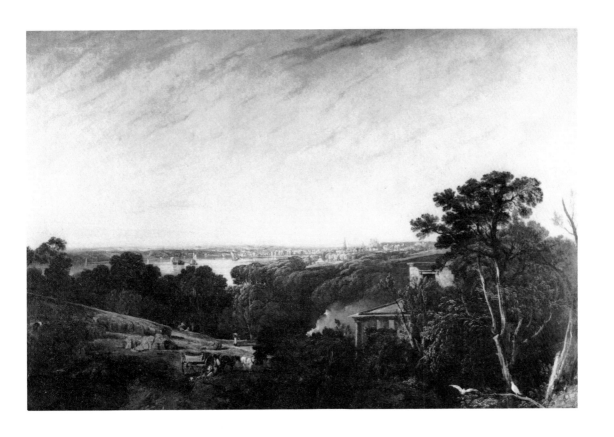

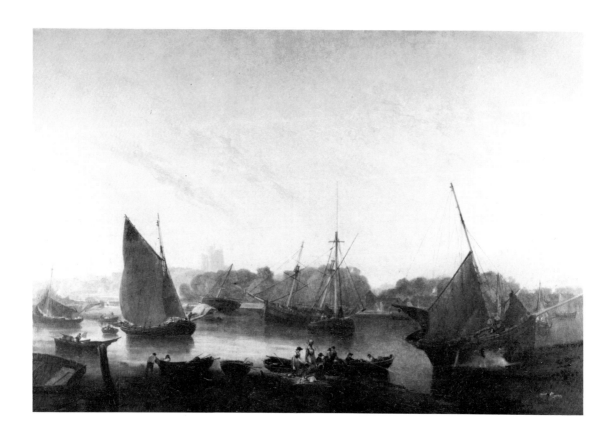

12 Itchen Ferry R.A. 1811

Oil on canvas; 122 × 183 (48 × 72)
Private collection (exhibited in a photograph)

Companion to 'Southampton from Weston Grove', and likewise painted for William Chamberlayne and shown at the Royal Academy in 1811 (112). The viewpoint is towards Southampton from across the Water; Lord Lansdowne's Southampton Castle, with its 'whimsical tower' added in 1804,[1] stands at the centre of the far bank. The effect is of sunset, and save for a dark foreground the entire canvas is suffused with a rich coppery glow; both the predominant tone, and the interest in form as conditioned by light

and atmosphere, take the painting very close to Turner, and Callcott may well have intended it as a sequel to the 'Sun rising through Vapour', to which his own work had been favourably compared (see No.6). Despite its size and complex composition, 'Itchen Ferry' shares with its companion a naturalism unusual in Callcott's early work.

[1] N. Pevsner, *Hampshire*, 1967, p.545.

13 Open Landscape: Sheep grazing B.I., 1812

Oil on canvas; 44.5 × 77.5 ($17\frac{1}{2}$ × $30\frac{1}{2}$)
York City Art Gallery.

Callcott wrote of this in his MS. catalogue as 'A small picture painted from nature and sold from the Exhibition at the British Gallery but I do not know by whom. It is now in the possession of [John] Allnutt Esq.' It must therefore have been the smaller of the two 'studies from nature' exhibited at the British Institution in 1812 (195). The subject is unknown, but the gently rolling country and silvery light seem to belong to southern England, perhaps to Hampshire.

The date of Allnutt's purchase of the sketch is also uncertain, since Callcott's note clearly implies that he did not buy it straight from the Institution exhibition. In 1843 Allnutt wrote to C.R. Leslie, describing it as 'very beautiful', and explaining how he had sent it to Constable, together with a painting by Constable himself, also bought some years earlier at the British Institution, with the request that Constable

should reduce the height of his own canvas to the same as the Callcott, enabling the two paintings to be hung as a pair.[1] As Allnutt further explained, Constable did not alter his, but painted an entirely new one of the same or more nearly the same size as Callcott's. This second version is identifiable with the 'Landscape: Ploughing Scene in Suffolk' at the Yale Center for British Art, while the original is the larger work of the same title shown at the Academy in 1814, and now exhibited with the Callcott (fig.17). The Callcott itself has never before been recognised, but its provenance and size, and appropriateness to the description in the Allnutt sale as 'an extensive open landscape', leave no doubt that it is the York picture.

The considerable pains Constable took to match his second version to Allnutt's Callcott, not only in size but also in colour, was mainly a

[75]

fig.17

tribute to a patron to whom he had cause to be grateful, for his reactions to Callcott and his work usually tended to be ambivalent or hostile. His mixed feelings about the 1807 'Market Day' (No.5) and the 1826 'Antwerp Quay' (No.19) are noted elsewhere; in the latter year he was open in his praise for 'Missing the Painter Rope' (fig.9), describing it as 'simple, grand and affecting',[2] but otherwise he found little to admire. He certainly recognised Callcott as an influential figure, but his hopes of securing him as an ally were frustrated; any praise Callcott gave Constable was usually strictly qualified. Thus in 1812 Constable was told by Callcott that 'my pictures had very respectable situations in the Academy & that they looked very well, but rather dark and heavy',[3] and that Callcott was not yet prepared to support his candidature as Associate; indeed in 1819 Constable told Farington that 'from what he had heard, he had no expectation that Callcott would ever vote for him'.[4] He had to wait until 1823, when he showed 'Salisbury Cathedral from the Bishop's Grounds', for a really encouraging word; 'Callcott admires my Cathedral; He says I have managed it well'.[5] But three years later Callcott chose to believe malicious rumours about Constable which had apparently emanated from his early mentor J.T. Smith, who had long since transferred his support to younger protégés like George Arnald and George Dawe. Leslie intervened with Callcott, and as a result Constable was received 'favourably by Mr. Callcott & . . . had the opportunity . . . of clearing away this

wretched nonsense . . . and of being restored to his friendship – and above all of being assured by him that I had much risen in his esteem'.[6] It was perhaps around this time (1826), and in this euphoric mood, that Constable painted his second 'Ploughing Scene' to accompany the Callcott. Later he began to betray real resentment at his continued failure to persuade Callcott to take his work seriously. In 1832 he wrote to Leslie that Callcott 'said I did not believe what I said, but only wished to attract attention by singularity'.[7] Having admitted so much, he allowed Leslie two glimpses of his true bitterness: 'who would not "rather rule in hell than obey in heaven"', he asked after John Landseer had told him of 'Callcott's commands, or dictations to vote for Linnell' in one of that artist's own numerous attempts at an Associateship,[8] and in another letter, Constable was frank in his scorn for Callcott and other contemporaries: 'What must I feel when I push my head against the clouds and [waves] of poor Callcott – or breath the stagnate sulphur of Turner – or smell the – of a publick house skittle ground by Collins – or be smothered in a privy by Linnell or Mulready – but let them alone, is best of all'.[9]

It is fortunate that Constable did not live to see Callcott's picture fetch three times as much as his own pendant in the Allnutt sale in 1863. The Callcott was acquired by Albert Levy, and sold again at Christie's, 6 April 1876 (lot 286), when it was bought by Agnew; it was subsequently in the collection of John Burton of York, who bequeathed it to the Art Gallery in 1882.

[1] Allnutt to Leslie, 2 February 1843, in Beckett, IV, p.83.
[2] Constable to Fisher, 22 April 1826, in Leslie, p.156.
[3] Constable to Maria Bicknell, 24 April 1812, in Beckett, II, p.65.
[4] Farington, 1 November 1819.
[5] Constable to Leslie, 9 May 1823, in Leslie, p.100.
[6] Constable to Leslie, undated, 1828, in Beckett, III, pp.15–16.
[7] Constable to Leslie, 9 April 1832, loc.cit., p.66.
[8] Constable to Leslie, 4 December 1832, loc.cit., p.84.
[9] Constable to Leslie, 17 December 1832, loc.cit., p.85.

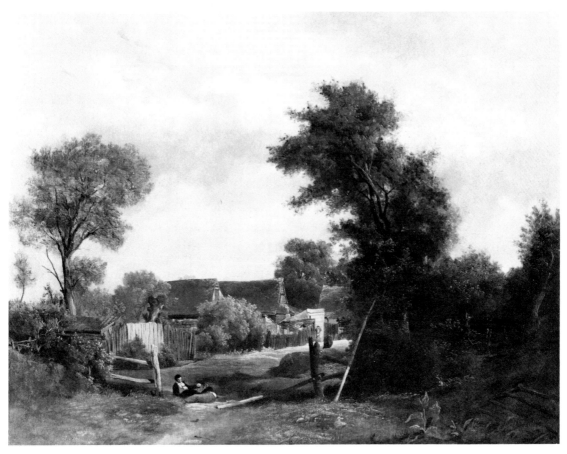

14　A Rural Scene; the Entrance to a Village　*c*.1812

Oil on canvas; 71 × 91 (28 × 35⅞) Private collection.

This painting, though certainly by Callcott and of quite early date, is not exactly identifiable with any of his exhibited works or with those described in his MS. catalogue. It is likely to have remained in the artist's hands since it is first recorded in the collection of his great-niece and her husband Isambard Kingdom Brunel. It subsequently belonged to Henry Wallace, to José de Murrieta, Marquis de Santurce, and to George A. Hearne of New York City, who presented it to the Metropolitan Museum in 1896. It was sold by the Museum in 1973 and returned to the U.K.

The 'Rural Scene' is unusual in Callcott's early work in being a relatively pure landscape without very pronounced picturesque or genre elements. In this respect, and also in its execution, it is very similar to 'Sheep grazing' (No.13), and although its size does not exactly correspond to the recorded measurements, it may have been the other 'study from nature' shown at the British Institution in 1812 (114). In these paintings Callcott has retained something of the freshness of an oil sketch; the lightness of touch in the trees and foliage, inconsequential mood of the figures, and general economy of detail are far removed from the elaborate, even monumental construction of landscapes such as the 1807 'Market Day' (No.5) or his 1811 diploma piece (No.10). The 'Rural Scene' was exhibited at the Royal Academy in 1883 (279, as 'The Farm').

15 The Entrance to the Pool of London R.A., 1816

Oil on canvas; 153 × 221 (60¼ × 87)
Signed *A.W.C.* on a piece of driftwood at lower right.
Trustees of the Bowood Settlement.

Exhibited at the Royal Academy in 1816 (175), this was the second of Callcott's series of large marines; it is certainly the finest of them and indeed ranks as one of the great 'tranquil marines' of the English school. It was commissioned by the 3rd Marquess of Lansdowne for 200 guineas following the great success of Callcott's 'Passage and Luggage Boats' at the Academy the previous year.

The 1815 painting, now lost, was by all accounts based on Cuyp, and Callcott had probably been inspired by that artist's 'Passage Boat', acquired by the Prince Regent as part of the Baring collection in 1814. In its composition and serene golden tone 'The Pool of London' also acknowledges Cuyp, and as Turner so often did, Callcott must have set himself to rival and reinterpret an old master. This was recognised by critics and fellow artists, and the painting attracted from the first comments of a strongly patriotic flavour. Thomas Uwins wrote to a friend that 'Callcott has fairly out-boated himself; his picture of the entrance to the port of London is quite as fine as anything Cuyp ever painted, or anything that has ever been done in this way, in any age or country'.[1] The Duke of Sussex singled out 'The Pool' for special praise in his speech at the Academy dinner,[2] and Farington noted that it was 'universally admired', even by Callcott's recent antagonist, Sir George Beaumont.[3] According to Thornbury, Turner, 'on being told that Callcott had painted one of his finest scenes on the Thames for two hundred pounds, observed in the presence of several patrons of the fine arts, "Had I been deputed to set a value upon that picture I should have awarded a thousand guineas"'.[4]

The Morning Chronicle, reviewing the 1816 exhibition, declared that 'Mr. Callcott's *Entrance to the Pool of London* is, perhaps, for clearness and beauty, the most valuable pro-

duction of his fine talent; it is universally admired; and so are the *Landscapes* of Mr. Turner, which by the strength of their colours will constantly increase in value as they shall be mellowed by time'.[5] On the other hand William Hazlitt drew in *The Champion* a fatal comparison between 'The Pool' and Turner's 'Temple of Jupiter Panellenius' (the Duke of Northumberland), remarking that 'Mr. Turner may now take useful lessons from Mr. Callcott, instead of Mr. Callcott from Mr. Turner',[6] and it is now axiomatic that Turner's 'Dort' (Yale Center; fig.18), shown in 1818, took up the challenge of Callcott's picture; I have already added the speculation that Turner's full title for the 'Dort' may have contained a more specific reference to Callcott, in particular to his long delay over the execution of 'Rotterdam' (No.17).

Callcott took considerably more pains over his marines than over his landscapes, and based them to a greater extent on direct observation. For 'The Pool' he depended both on studies and on ship models. In November 1815, Mulready told Farington that Callcott had had 'beautiful models of boats made, & proceeds in collecting the materials for His picture so as to make it as perfect as He can';[7] by the end of his life Callcott seems to have possessed a fine collection of models, five of which were bought at his executors' sale by E.W. Cooke.[8] No direct composition study for 'The Pool' is known today, a highly finished watercolour given by Callcott to Lady Lansdowne being most probably a replica of the completed picture; but the oil sketch described below and a watercolour of barges and rafts in the Whitworth Art Gallery, Manchester (D.70. 1892 (118)) probably represent the kind of 'materials' Mulready referred to.

The Redgraves named 'The Pool' with the lost 'Mouth of the Tyne' shown in 1818 (fig.6) as

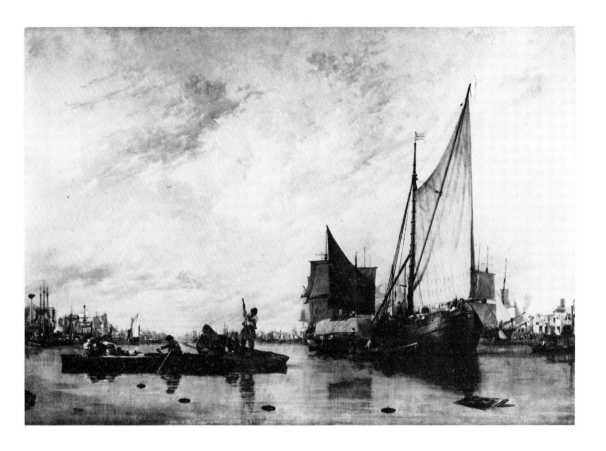

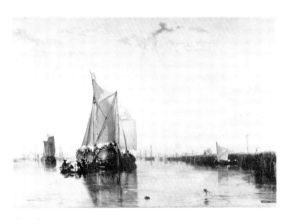

fig.18

among Callcott's 'finest pictures' which 'un-
doubtedly raised his reputation to the first rank',
adding that they had 'an individuality of their
own and an appreciation of English atmosphere

and English scenery not to be found in the works
of his later years'.[9] 'The Pool' was also noticed
by Passavant and Dr Waagen.[10] It was shown at
the International Exhibition, 1862 (193), at the
Royal Academy, 1884 (49), and most recently at
Somerset House in *London and the Thames*,
1977 (52).

[1] *The Memoirs of Thomas Uwins*, 1858, p.44.
[2] Farington, 27 April 1816.
[3] *Ibid.*, 26 April 1816.
[4] Thornbury, p.275.
[5] *Morning Chronicle*, 1 May 1816.
[6] *The Champion*, 12 May 1816.
[7] Farington, 8 November 1815.
[8] Extracts from Cooke's MS. diary were kindly
 furnished by Mr David Cordingly.
[9] Redgrave, p.342.
[10] Passavant, I, p.313; Waagen 1854, III, p.165.

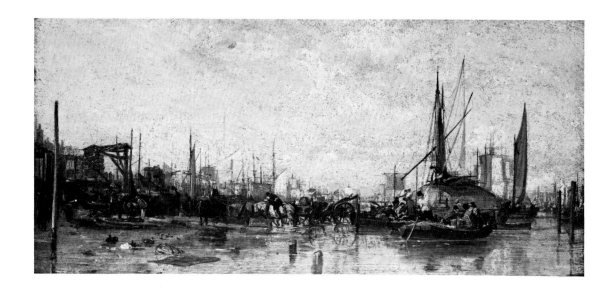

16 The Pool of London at low Tide *c*.1815

Oil on board; 25.4 × 55.7 (10 × 21$\frac{7}{8}$)
Private collection.

As recorded in a label on the back, this was bought by S.J. Loyd (1st Lord Overstone) at the Callcott executors' sale in 1845. It was seen in his collection by Waagen,[1] and subsequently passed to Lord Wantage, 2 Carlton Gardens.[2] It is a brilliant work, in no way put in the shade by the oil sketches of Turner and Constable, and its spontaneity and observed detail can leave little doubt that it was painted on the spot. The composition is much more elaborate, the river life more bustling, than in 'The Pool of London' (No.15), but the grouping of the larger boats on the right and the treatment of the sky, bright blue flecked with pinkish clouds, anticipate the arrangement and Cuyp-like effect of the finished picture. Despite its beauty, Callcott himself evidently attached no importance to this sketch once it had served its turn; a family friend, the musician and amateur draughtsman Dr William Crotch, who made a copy of it when it appeared in the 1845 sale, noted that it 'was found put away in a lumber room all over dirt'.[3]

The sketch was shown with the large 'Pool' at Somerset House, *London and the Thames*, 1977 (53).

[1] Waagen 1857, p.136.
[2] A.G. Temple, *A Catalogue of Pictures forming the Collection of Lord and Lady Wantage*, 1902, p.32, No.35.
[3] Crotch sketchbook of copies after Callcott made in 1845, Norwich Central Library, Nor. MSS, 11088, p.45.

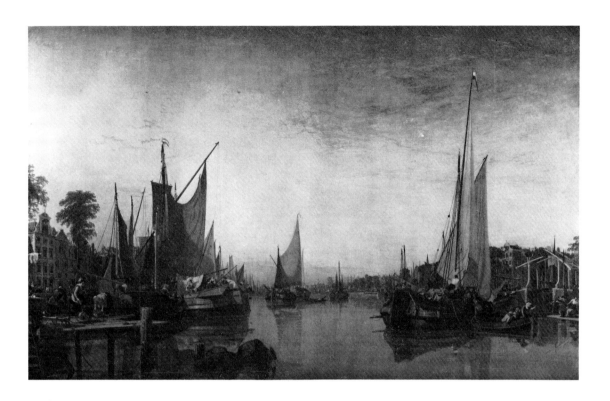

17 Rotterdam R.A., 1819

Oil on canvas; 157×221 ($61\frac{3}{4} \times 87$)
Private collection.

This picture, exhibited at the Royal Academy in 1819 (86), had first been commissioned by Charles, 2nd Earl Grey in 1816, following the success of 'The Pool of London' (No.15). Callcott stayed with his patron at Howick in August 1816 to discuss the commission, but did not begin work until he could spare time to visit Rotterdam to make the necessary studies. This he did in the late summer of 1818, spending four days in and around the port, which he described to Farington as 'large as Bristol, with very good inns'.[1] The painting was finished by the following spring. Earl Grey had originally agreed a price of 250 guineas,[2] which, though more than Callcott had received for 'The Pool of London', was still low for so large a canvas. In 1819 Callcott doubled the figure to 500 guineas, the

same sum Turner had received for the 'Dort' the previous year, but the Earl was happy to comply, and was reported as being 'in raptures' with the finished work.[3]

'Rotterdam' is unique in Callcott's production in that its genesis can be traced back to an on-the-spot drawing (private collection; fig.19) and thence through the oil sketch also exhibited (see the following). The view is of the Leuvehaven with the church of St Lawrence (the Groote Kerk) on the right. In the final painting Callcott retained the essential structure of the composition in both sketches, with the jetty and mooring posts in the left foreground, the two main groups of barges at left and right and the more distant group in the middle of the harbour, but took his view from further down

the Leuvehaven so that the tower of St Lawrence appears in the far distance; he also made the harbour seem far wider, so that the effect is more impressive. The simple monumentality of 'The Pool of London' has given way to a mass of detail and incident, and 'Rotterdam' might strike the modern eye as a rather self-important picture. Nevertheless it is a major achievement and something of a contemporary document; its insistent sense of actuality and rich colour, revealed by recent cleaning, impress it irresistibly on the memory.

The painting was a considerable success at

fig. 19

the Academy. Published reviews were generous; Callcott's friend Thomson considered it his best work so far;[4] and Henry Crabb Robinson observed in his diary that although Turner's exhibits, 'Entrance to the Meuse' and 'England: Richmond Hill' (both in the Tate Gallery) had 'fewer attractions than he used to have', this was compensated for because 'Callcott's *Rotterdam* is grander than he used to be'; he did however add that Callcott 'is aiming at a richer cast of colour, but is less beautiful as he deviates from the delicate greys of Cuyp'.[5] 'Rotterdam' was etched by George Cooke in 1826, and exhibited at the Academy again in 1896 (10); it was confused by Dafforne with its preparatory oil sketch.[6] A different view of the port was painted for the Earl of Essex and shown at the Academy in 1823 (whereabouts unknown).

[1] Farington, 5 May 1819.
[2] *Ibid.*, 1 May 1816.
[3] *Ibid.*, 3 April 1819.
[4] *Ibid.*
[5] *Diary, Reminiscences and Correspondence of Henry Crabb Robinson*, I, 1872, p.329.
[6] Dafforne, pp.19 and 47.

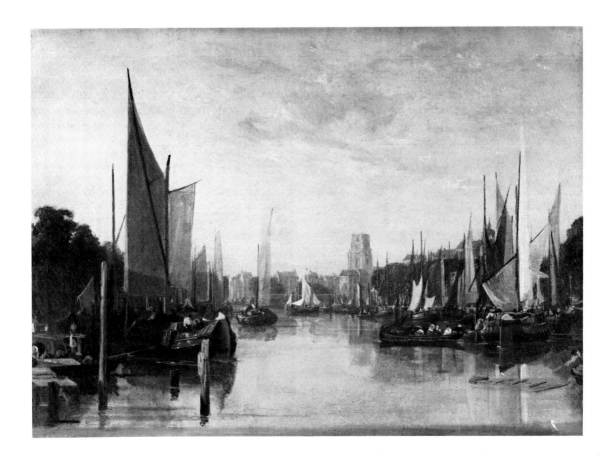

18 Rotterdam *c.*1818–19

Oil on canvas; 48.2 × 71 (19 × 28)
Mrs Guy Knight.

With the oil sketch of 'The Pool of London' (No.16) this was bought by S.J. Loyd (1st Lord Overstone) at the Callcott executors' sale in 1845, and was seen in his collection by Waagen;[1] it later passed to Lord Wantage,[2] and has since remained in the Loyd collection. As it is on canvas and of fairly substantial size, the sketch is unlikely to have been painted on the spot, and is more probably a studio development of the pen and ink drawing which Callcott made while in Rotterdam (private collection; fig.19). With the variations already noticed, Callcott used the composition for No.17. In its warm colouring and painterly handling the sketch is a delightful painting in its own right, although Callcott must have thought of it as purely functional, and took few pains to hide several pentimenti, the most interesting of which, as it anticipates the finished picture, is the introduction of the lock gates at extreme right, over the sail of a barge. Dr William Crotch, who made a copy of the sketch before the 1845 sale, thought it 'better than the [finished] picture'.[3]

[1] Waagen 1857, p.136.
[2] A.G. Temple, *A Catalogue of Pictures forming the Collection of Lord and Lady Wantage*, 1902, p.23, No.34 repr.
[3] Crotch sketchbook, *loc.cit.* under No.16 above, p.48.

19 The Quay at Antwerp during the Fair Time R.A., 1826

Oil on canvas; 137 × 198 (54 × 78)
The Marquess of Tavistock, Woburn Abbey, Bedfordshire.

Exhibited at the Royal Academy in 1826 (102), this had been commissioned by John, 6th Duke of Bedford for his gallery of modern British pictures at Woburn. Encouraged by his second son, Lord William Russell, who had ordered a painting from Callcott as early as 1805, the Duke began collecting examples of living artists around 1820, and, by his death in 1839, had acquired works, mainly narrative pictures, by Eastlake, C.R. Leslie, G.S. Newton, William Collins, William Hayter, Abraham Cooper, William Allan and Wilkie among others. His taste, as some of these names will suggest, was inclined to be conventional, and although he did buy landscapes, notably those of F.R. Lee, he totally ignored Turner and Constable. Letters from Lord William to Joseph Severn about his own contribution to the Woburn gallery, 'An Italian Vintage', amply convey the cautious spirit in which his father approached his collecting. The painting was to hang, he wrote in 1825, in a 'chamber fitted purposely for pictures of the most approved modern artists',[1] and on a second occasion he referred to these painters as those 'most distinguished'.[2] Clearly the Duke was worried by anything controversial, and it is easy to see why he turned to Callcott rather than to Turner for a view of Antwerp Quay. In the series of large canvases he had exhibited since 1815, Callcott had established himself as an undoubted master of the sea-port scene, but one who was more descriptive in his details and realistic in his colour than Turner was when treating similar subjects – a point which must have emerged very clearly in the 1826 exhibition when the sober 'Antwerp' could have been compared to Turner's vivid 'Cologne' (Frick Collection).

'Antwerp' was the first truly marine subject to enter the Duke's collection, although in 1825 he had acquired William Collins's 'Buying Fish on the Beach, hazy Morning'; in 1829 these pictures were joined by the Duke's most adventurous and unexpected purchase, a Bonington 'Scene on the French Coast' from the artist's sale. Both additions were probably made on Callcott's advice. He was by now a friend of Collins, and Waagen was correct in noticing that Collins's painting at Woburn 'successfully approximates to the style of Callcott';[3] he must also have known Bonington, perhaps through his early acquaintance Francia, for in 1826 he advised both the Duke and Lord Holland, when in Paris, to visit his studio, and praised his work highly.[4] Callcott received his own commission from the Duke in 1824, and that year he visited Holland to make the necessary studies; 'My friend Callcott went over to Holland last year on purpose for a view of the Port of Antwerp', Lord William Russell wrote to Severn in 1826, meaning to say the year before last.[5] The majority of the paintings commissioned for the Woburn gallery were small in size, and Callcott's larger work was intended to be one of its major set-pieces, an authoritative and even synoptic picture which was to exemplify the English fascination for the Dutch tradition. It does, indeed, look like an old master. The potential ambiguity of the phrase 'Fair Time' given in the title would not have escaped Callcott; there is little of purely contemporary significance in the painting, and it seems to have been designed to bridge the gap between the seventeenth and nineteenth centuries, and to evoke a nostalgia which relates the 'Fair Time' subject to the 'olden time' taste of a few years later.

As in 'Rotterdam' (No.17), the entire canvas is highly worked and full of detail. Such elaboration comes at the expense of vigour and spontaneity, and the tonality is in a low key throughout – which may have been what

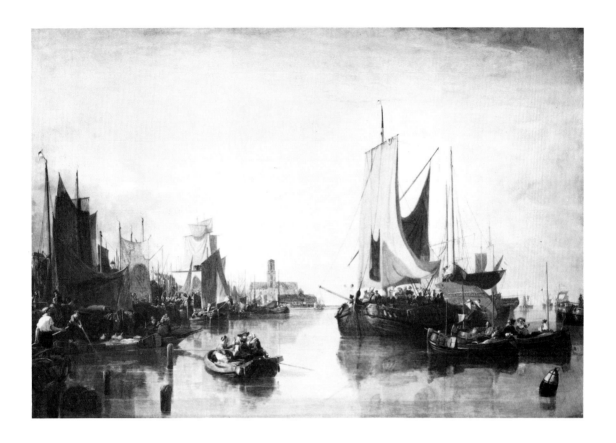

Constable meant when he described the painting as 'rather too quakerish, as Turner is too yellow'; he did however add that 'every man who distinguishes himself stands upon a precipice'.[6] At Woburn, 'Antwerp' took its place in a major (but little remembered) modern collection, widely accessible in its day; it was twice seen by Waagen,[7] and the room where it hung was one of the two used by Queen Victoria and Prince Albert during their visit to the house in 1841. It was listed in the 1831 Woburn *Guide*, and in George Scharf's 1877 catalogue;[8] it was exhibited at the British Institution, 1845 (135) and at the Manchester Art Treasures

Exhibition, 1857 (207, as 'The Scheldt, near Antwerp'); a lithograph was published by T.C. Dibdin.[9]

[1] Russell to Severn, 21 September 1825. Houghton Library, Harvard University.
[2] Russell to Severn, 23 January 1826. *Loc.cit.*
[3] Waagen 1838, III, p.344.
[4] Holland House Papers. British Library.
[5] Russell to Severn, 23 January 1826. *Loc.cit.*
[6] Constable to Fisher, 22 April 1826, in Leslie, p.156.
[7] Waagen 1857, p.31, and *op.cit.* above.
[8] G. Scharf, *A Descriptive and Historical Catalogue of the Collection of Pictures at Woburn Abbey*, part II, 1877, pp.205–6, No.335.
[9] Dibdin, pl.5.

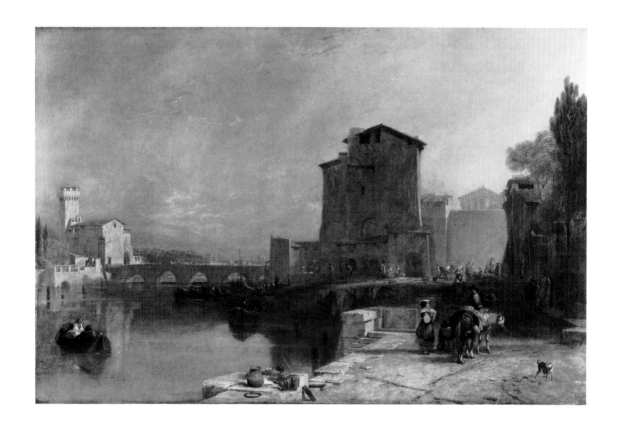

20 The Entrance to Pisa from Leghorn R.A., 1833

Oil on canvas; 106.7 × 162.5 (42 × 64)
Tate Gallery.

Exhibited at the Royal Academy in 1833 (185), this painting had first been commissioned by a Mr Morrison, very probably the James Morrison who by then owned Turner's 'Pope's Villa' and 'Thomson's Æolian Harp'. He did not however claim it and it was purchased from the exhibition by Robert Vernon, who possessed in all eleven pictures by Callcott, nine of which formed part of his bequest to the National Gallery in 1847, and were transferred with it to the Tate in 1919. Pisa is an excellent example of the several direct and topographically faithful subjects Callcott based on his continental tour of 1827–8, and might be compared to the pure

Italian landscapes of his friend Eastlake. The view is of the Torre di Guelfa and the Ponte a Mare, with the left bank of the Arno in the foreground. The Callcotts were in Pisa in April, 1828, towards the end of their tour of Italy; while there they met the engraver and historian Carlo Lasinio, and visited the Campo Santo with him. The picture was noticed by Waagen[1] and Dafforne,[2] and engraved by J.C. Bentley.[3]

[1] Waagen 1854, I, p.386.
[2] Dafforne, p.61.
[3] *Vernon Gallery*, I, No.54.

21 An Inn Door near Gravesend *c*.1830−35

Oil on board; 11.5 × 29.9 ($4\frac{1}{2}$ × $11\frac{3}{4}$)
Victoria and Albert Museum.

This small oil of *c*.1830−35 was bought by John Sheepshanks, who, with Robert Vernon, was the most generous of Callcott's patrons among the newly rich commercial classes, owning in all twelve of his paintings (see also No.23). The 'Inn Door' must be one of the '3 small sketches painted of various subjects at Gravesend purchased by John Sheepshanks Esqr.', listed in Callcott's MS. catalogue at some point in the 1830s. Despite the precise topographical origin, it is characteristic of Callcott's later cabinet pictures in avoiding any contemporary features and rather evoking the Dutch seventeenth century; indeed Dafforne considered the subject to be Dutch, notwithstanding Callcott's specific title.[1] The picture was lithographed by T.C. Dibdin.[2]

[1] Dafforne, p.37.
[2] Dibdin, pl.9.

22 Dutch Sea Coast $c.1830-35$

Oil on board; 16×24 ($6\frac{1}{4} \times 9\frac{1}{2}$)
Tate Gallery.

This delightful sketch cannot be identified in Callcott's MS. catalogue, but probably dates from the early 1830s. It belonged to Robert Vernon, and in a manuscript list of his collection it was described as a copy from 'Van der Velde', presumably Adriaen, and said to be taken from a point on the north side of the Scheldt near Flushing.[1] The figures and boats certainly belong to the seventeenth century, but the fact that the very thin paint shows up under-drawing in pencil different from the painted composition would seem to weigh against the picture being a straight copy, and no exact prototype has been found. Nevertheless its ancestry may clearly be traced to Adriaen's Scheveningen subjects, or to a painting like the National Gallery's Jacob van Ruisdael of 'The Shore at Egmond-aan-Zee'. The sketch was engraved by J.C. Bentley for *The Vernon Gallery* as 'Sea Shore in Holland',[2] and also reproduced by Dafforne.[3]

[1] *Vernon Gallery*, II, under No.33 repr.
[2] *Loc.cit.*
[3] Dafforne, p.52.

23 Dort R.A., 1842

Oil on panel; 31.8 × 76 (12½ × 30)
Signed and dated at l. lower corner *A W Callcott 1841*.
Victoria and Albert Museum.

Exhibited at the Royal Academy in 1842 (262), a year when Callcott summarised his lifetime's achievements in landscape, sending also 'An Italian Evening' (Harrogate Library and Art Gallery) and an untraced 'English Landscape: Cows at the Watering Place'. The 'Dort' was bought by John Sheepshanks, for whom it must have had a special appeal as he was a great collector of Dutch prints of the seventeenth century (his collection was bought by the British Museum in 1836). Like the small 'Coast' (No.22), this is a cabinet picture designed to appeal to a specific 'old master' taste. Dort was Cuyp's home town, and Callcott's view of it across meadowland on a hazy summer morning is one of the most Cuyp-like of all his paintings; indeed the *Art Union* commented in its review, 'Surely this is beating Albert Cuyp on his own ground'.[1] The paint has turned somewhat waxy with age, but originally this must have been the kind of picture the Redgraves had in mind when they spoke of Callcott's works being 'always pleasing in our dark rooms'.[2] The subject was lithographed by T.C. Dibdin.[3]

[1] *Art Union*, IV, 1842, p.124.
[2] Redgrave, p.345.
[3] Dibdin, pl.3.

LUMB STOCKS (1812–1892) after Callcott

24 Raphael and the Fornarina

Engraving; 61 × 40.7 (24 × 16)
James Miller, Esq.

Exhibited at the Royal Academy in 1837 (104), 'Raphael and the Fornarina' was one of Callcott's two large late historical compositions, the other being 'Milton dictating to his Daughters', shown in 1840. Although Lady Callcott had no doubt that the 'Milton' was her husband's 'most intellectual' picture, 'far surpassing the Fornarina in those qualities that I could wish painting in this country to arrive at',[1] the two subjects were certainly intended to be complementary; indeed there was a precedent for the connection, for in 1817 Henry Joseph Fradelle had exhibited paintings of both at the British Institution.

The composition of Raphael and his mistress occupied Callcott for several years. A first version is recorded in his MS. catalogue as having been painted for the Duke of Norfolk; this was on two canvases, presumably one for each figure, divided by a strip of beading. The exhibited picture, apparently a single canvas with life-size figures, was completed on commission from Sir George Phillips. Neither version is known today. Callcott's interest in the subject could have come from a variety of sources. He would have remembered Turner's 1820 'Rome from the Vatican. Raffaelle accompanied by La Fornarina, preparing his pictures for the decoration of the Loggia' (Tate Gallery), but his picture has none of the programmatic content of the Turner. Nor, though more in their anecdotal tradition, does it conform very closely to the paintings of the same subject by Ingres, N. Brockendon or Fradelle, all of which include some direct reference to Raphael's own portrait of the Fornarina; Fradelle's canvas, typical of the iconography of the subject, had borne the caption: 'La Fornarina is distinguished by the intimacy with which she lived with Raphaelle. He is here represented in the act of painting the celebrated picture of her, which

is preserved in the Ducal Gallery at Florence', and Brockendon's version showed her 'observing the progress of her portrait in Raphael's study'. In Callcott's painting, however, Raphael is presented in his orthodox eighteenth-century guise, as a draughtsman, making the preparatory sketches for the portrait, and the main concern is not with a particular episode in Raphael's life, but with romantic love as it bears upon artistic inspiration, a theme already expressed in relation to Raphael by the poet Leigh Hunt, who in 1820 had written of Raphael's love for the Fornarina and spoken of him painting 'as it were, in the light of her eyes'.[2] (Hunt was a particular friend of Callcott, whose portrait of him is in the London Library).

Callcott's 'Raphael' is an important example of that historicism in the arts which occurs often in English and continental painting of its period, and is clearly related to the art-historical interests he shared with his wife and friends. In 1832 he had been visited by J.D. Passavant, whose monumental life of Raphael first appeared in 1839; Thomas Lawrence's collection of drawings by the master was well known to him; Leigh Hunt also had aspirations as a collector, and had, furthermore, written a sonnet on an engraving of Raphael as a young man; and, visiting the collection of Jean-Baptiste Wicar in Rome in 1828, Callcott would almost certainly have seen the Raphael drawing of the head of a youth now in the Ashmolean Museum, which may already have attracted the legend that it was an early self-portrait by Raphael. Callcott would also have known Sebastiano del Piombo's 'Raphael with the Fornarina' then in the Northwick collection, if only through the 1828 mezzotint by S.W. Reynolds, but although this probably provided an additional compositional source, the features of Callcott's Raphael conform to no very clear

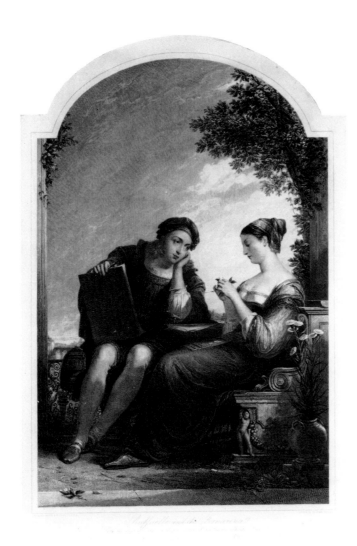

type; the Fornarina herself, however, is obviously posed after Sebastiano's portrait in the Uffizi, which the Callcotts would have regarded as by Raphael himself.

Finally, Callcott's picture must have owed much to his experience of modern German art during his continental tour, an interest he shared with his friend William Dyce, whose 'Paolo and Francesca' (National Gallery of Scotland), with its faintly similar grouping of the figures, was also exhibited in 1837, at the Scottish Academy. Both Dyce and Callcott were aware of the same Nazarene prototypes, and however decorative and sentimental Callcott's painting must have been, it is difficult to avoid seeing in its massive seated figures an echo of Pforr's design for an 'Allegory of Friendship', or of Overbeck's 'Italia and Germania'.

Lumb Stocks's engraving was published in 1843 by the Art Union of London.

1 Maria Callcott to an unknown correspondent, 19 May 1840. Royal Academy Library, Callcott papers, CA/4/41.
2 Hunt in *The Indicator*, II, 22 November 1820.

Publications referred to in abbreviated form

Beckett R.B. Beckett, *John Constable's Correspondence*, Suffolk Records Society, vols issued from 1965.

Brown 1975 D. Brown, 'Turner, Callcott and Thomas Lister Parker; New Light on Turner's "Junction of the Thames and Medway" in Washington', *Burlington Magazine*, CXVII, 1975, pp.719–22.

Butlin and Joll M. Butlin and E. Joll, *The Paintings of J.M.W. Turner*, 1977.

Cook and Wedderburn E.T. Cook and A. Wedderburn, *The Works of John Ruskin*, 1–39, Library Edition, 1903–12.

Dafforne J.C. Dafforne, *Pictures by Sir Augustus Wall Callcott, R.A., with a Biographical Memoir*, 1876.

Dibdin T.C. Dibdin, *Sir Augustus Wall Callcott's Italian-and English Landscapes. Lithographed by T.C. Dibdin*, 1847.

Farington J. Farington, *Diary*, ed. J. Grieg, 1922–8, and unpublished typescript in British Museum Print Room.

Finberg A.J. Finberg, *The Life of J.M.W. Turner R.A.*, 1961 ed.

Gage, *Correspondence* J. Gage, *Collected Correspondence of J.M.W. Turner*, 1980.

Gage 1965 J. Gage, 'Turner and the Picturesque', parts I and II, *Burlington Magazine*, CVII, 1965, pp.16–26 and 75–81.

Gage 1968 J. Gage, 'Turner's Academic Friendships: C.L. Eastlake', *Burlington Magazine*, CX, 1968, pp.677–85.

Hall D. Hall, 'The Tabley House Papers', *Walpole Society*, XXXVIII, 1960–2, pp.59–112.

Horsley J.C. Horsley, *Recollections of a Royal Academician*, ed. Mrs E. Helps, 1903.

Leslie C.R. Leslie, *Memoirs of the Life of John Constable*, ed. J. Mayne, 1951.

Passavant G. Passavant, *Tour of a German Artist in England*, 1832.

Redgrave R. and S. Redgrave, *A Century of Painters of the British School*, 1890 ed.

Stephens F.G. Stephens, *Memorials of William Mulready*, 1867.

Thornbury W. Thornbury, *The Life and Correspondence of J.M.W. Turner R.A.*, 1877 revision reprinted 1970.

Vernon Gallery *Vernon Gallery of British Pictures*, ed. S.C. Hall, 1851–3.

Waagen 1838 G. Waagen, *Works of Art and Artists in England*, 1838, I–II.

Waagen 1854 G. Waagen, *Treasures of Art in Great Britain*, 1854, I–III.

Waagen 1857 G. Waagen, *Galleries and Cabinets of Art in Great Britain*, 1857.

Wilton A. Wilton, *The Life and Work of J.M.W. Turner*, 1979.

A note on archival sources

A large number of papers by and concerning Callcott have survived, for the most part in the collections of his several indirect descendants. There follows a list of the principal documentary sources for his life and work, some of which have been referred to in the foregoing text. Unless otherwise stated, these papers are presently on deposit in the Department of Western Art, Ashmolean Museum, to which enquiries concerning them should in the first instance be directed. For convenience the papers are divided into 'personal' and 'professional' categories, although these are obviously not mutually exclusive.

Personal papers
Fragments of Family History written by Sir Augustus Wall Callcott R.A. a few years before his death in 1844; transcription by William Hutchins Callcott.
Journal for July 1805.
Journal of visit to Paris, 1815; MS. fragments and a more complete typed transcription, probably made by Mrs R.B. Gotch.
Sir A.W.C.'s Dictionary of Anecdotes.
Fuseli; uncomplimentary note about Fuseli as an Academy lecturer.

Professional papers
Sir A. Callcott's Catalogue; a list, not entirely complete, of Callcott's paintings and their purchasers, divided into exhibited and unexhibited works.
Account of Turner's Academy exhibits of 1799, with outline sketches; written for Mr T. Bennet, an artist from Woodstock.
Letter to an unknown correspondent on landscape painting, July 1801.
A series of letters, perhaps to the same correspondent but dated 1804 and 1805, on the need for rules and principles in art.
Notes on the history of colour in painting.
A notebook with quotations from the Bible, classical authors etc. on art and artists; also containing a list of Callcott's patrons.
A list of Callcott's personal collection of paintings by himself and other artists, compiled in 1827.
A list of Callcott's library, with prices paid for books.
A large bound notebook containing notes of technical interest, quotations from Reynolds, and an account of Benjamin West's rainbow theory lecture of 1817.

A certain amount of Callcott material also exists in the libraries of the Royal Academy and the Victoria and Albert Museum (chiefly among the Eastlake papers). The very extensive papers of Maria Callcott, on deposit with Callcott's own in the Ashmolean Museum, are not itemised here; for her journals of her honeymoon tour with him in Germany and Italy in 1827–8, the reader is referred to the microfiche transcription edited with an introduction by D. Brown and C. Lloyd, forthcoming from Oxford Microform Publications Ltd.

List of Lenders

Trustees of the Bowood Settlement 15
Herbert Art Gallery, Coventry 6
Mrs Guy Knight 18
James Miller 24
National Trust 9
Private collection 14, 16, 17
Royal Academy of Arts 10
Tate Gallery 7, 20, 22
The Marquess of Tavistock 19
University of Manchester 5
Victoria and Albert Museum 2, 21, 23
Yale Center for British Art 1, 8
York City Art Gallery 13